Professional Photography: A Practical Guide

Barry Buchanan
Honorary Life Member,
Australian Journalists Association

ISBN : 978-1-4092-9544-0

Copyright ©2009 Barry Buchanan

Dedication

In loving memory of my wife of nearly half a century,
Patricia May Buchanan

To family and friends,
former colleagues of Network Ten, Sydney, and
everywhere else I have worked

And

To everyone who enjoys photography and wants to
become a professional photographer

Thanks

To my son James, for all sorts of computer help, who is also
a professional member of the Australian Journalists Association

And

The staff of Lulu Enterprises, Inc. for their patient help and advice in the
production of this book. Any errors are mine, and if you spot any,
please send me an email: tvstills@gmail.com

Principles of Professional Photography

First, your camera must become an extension of your arm. You must always be ready to capture that moment which distinguishes you as a professional from the "good" hobbyist photographer. If you don't get the shots, and the best ones, consistently, your freelance opportunities or salaried position may disappear very quickly.

When speaking of capturing a moment, that is precisely what it suggests. The opportunity to take a great shot of a celebrity standing coolly next to an elephant may never present itself again. You're always ready to get that type of shot as a professional.

You are also essentially part of the publicity machine. For example, a shot of a knighted talk show host embracing a world known celebrity singer will be circulated and by extension result in free advertising and publicity for the paper, television station or media website you work for. Otherwise, your employer will always be paying for advertising to attract and retain an audience.

You should be a gregarious person. You must have the ability to "bounce off people" and talk to them easily. Over the span of your career, you must be prepared to meet every type of person from "John Doe" to a reigning monarch.

When working as a professional, say for a television station, often you will be taking shots of people who are photographed wherever they go. You do not have the luxury of asking them to pose in a certain way. It's your job to get in, be quick on the draw with your camera, and get out the way.

This book will teach the new or aspiring professional photographer in pictures. They show how the job is done, and you should begin by doing – taking photographs, and lots of them. Pictures may have comments or captions when they have something subtle to say about the job, which might not be immediately obvious. Good luck! But really, it's not luck. It's all hard work. Enjoy yourself, take a lot of photographs, remember the basic principles, and you will surely be successful.

Be quick on the draw

Snap quickly, snap often. Always be ready for an opportunity that may never present itself again. Some photographs look carefully planned, staged and perfectly framed, even when they feature animals. This couldn't be further from the truth. *Carpe diem*! (seize the day or moment in time), but do be concerned about the result. That is one characteristic which separates the professional from the amateur. Get plenty of practice. You have to get the shot without notice, but it also has to be good!

A good example of being ready and fast.

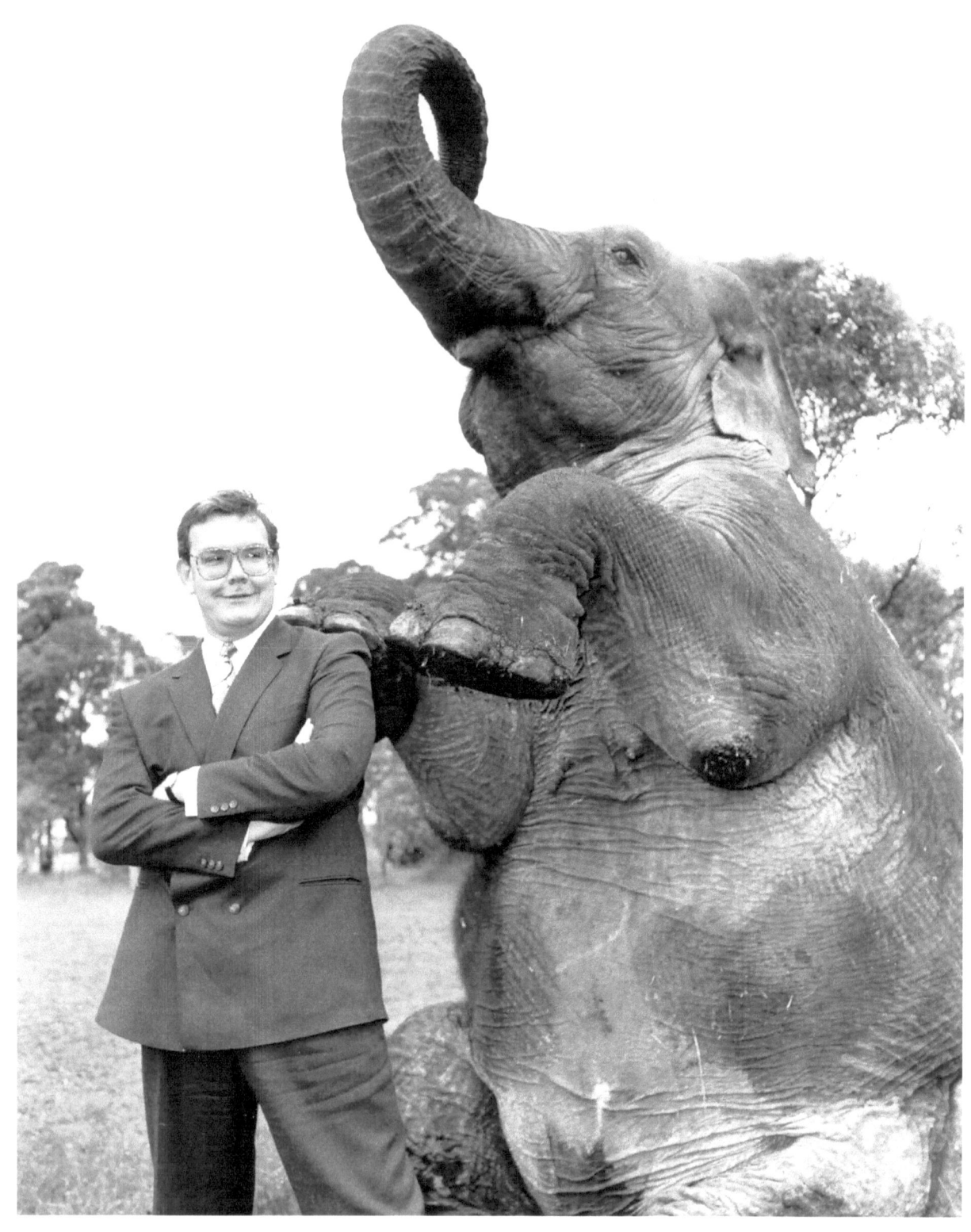

Quick! The opportunity to take a shot like this may never happen again.

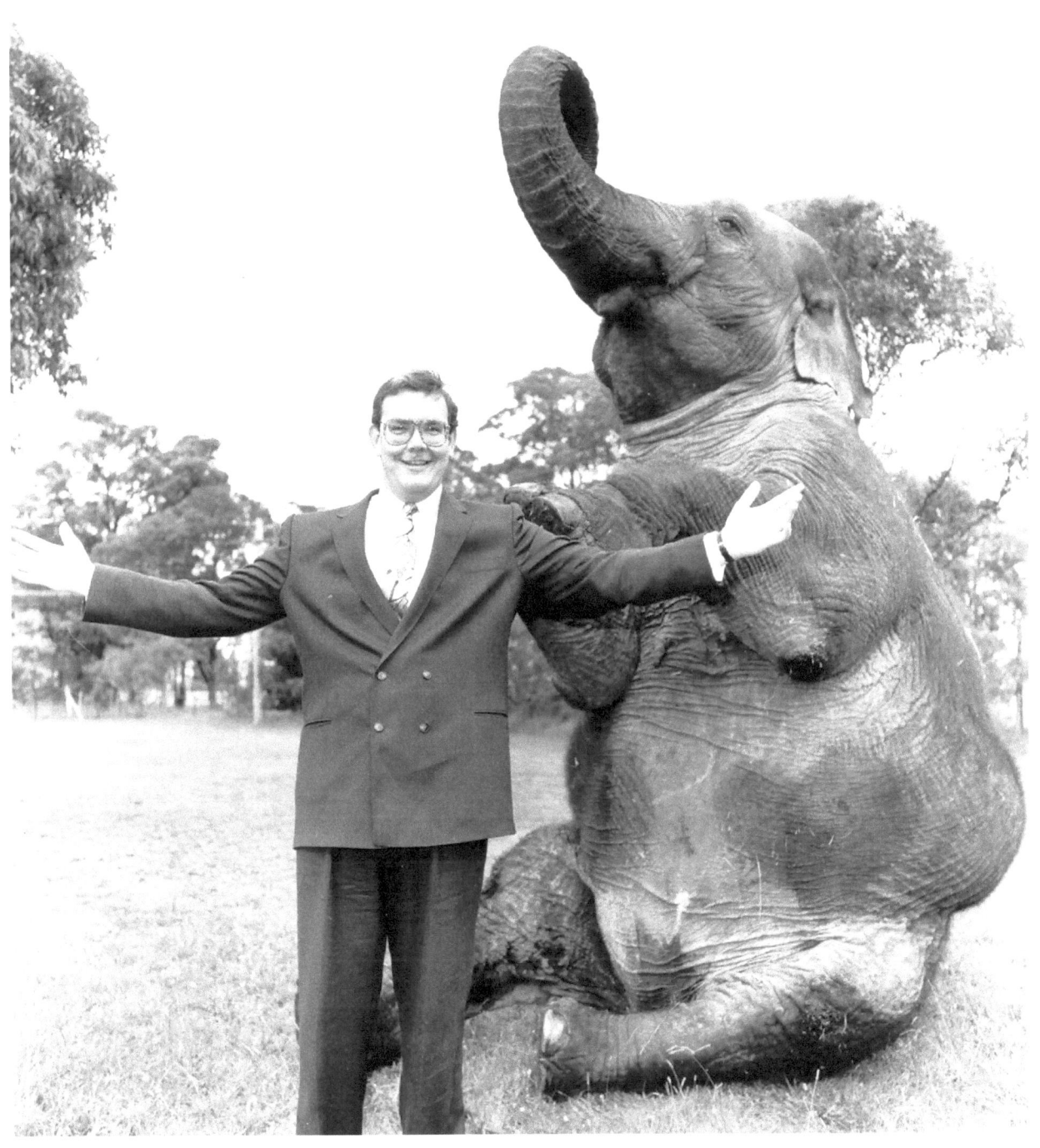

And Gordon Elliott's OK, too!

Another reason to be ready and fast is, if you'll pardon the pun, the elephant in the living room. Even if animals are trained, they can be unpredictable. Always be careful with large or "tamed" wild animals.

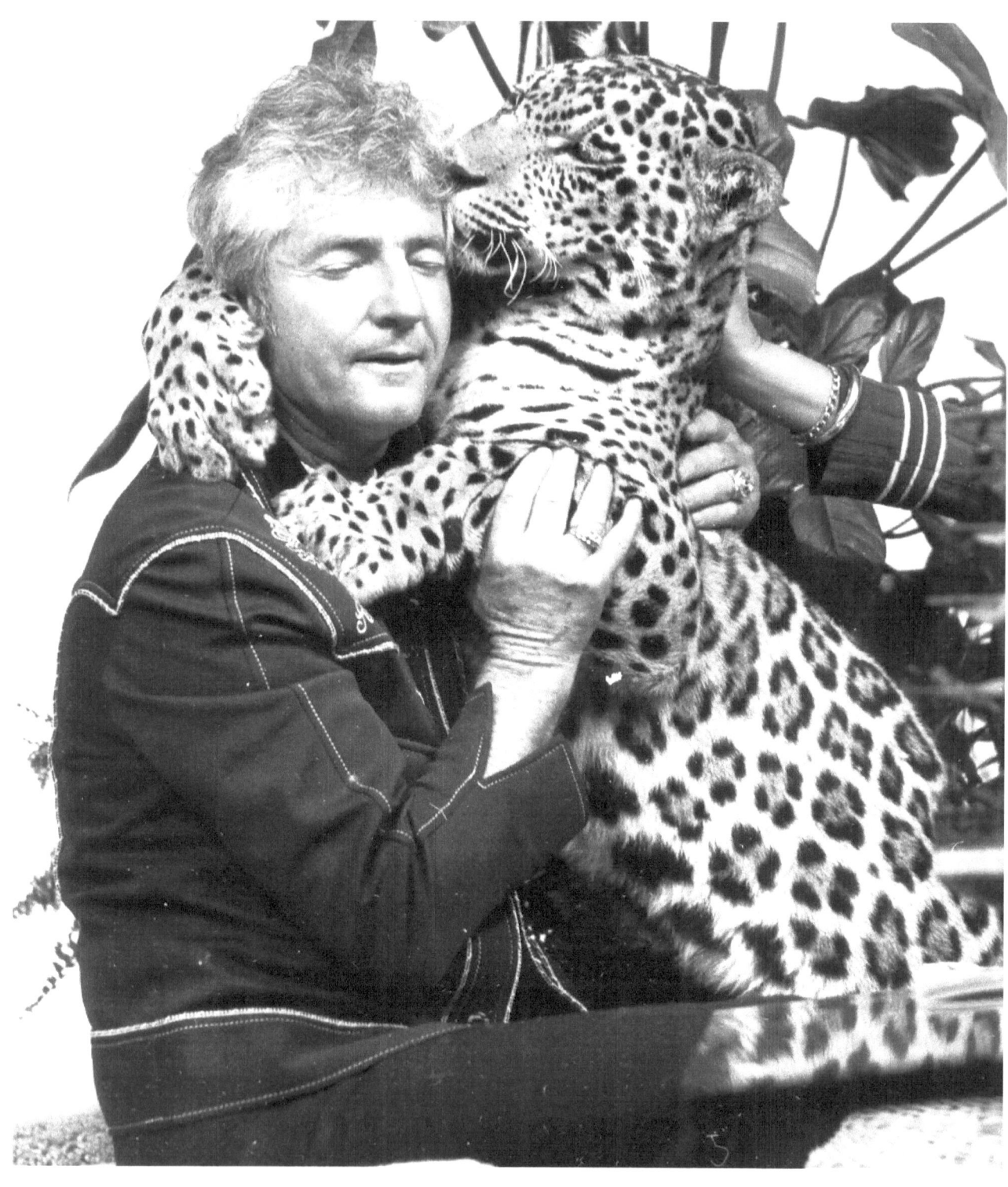

How often do you think you'd get a shot of someone getting a cuddle and a kiss from a leopard?

When you can consistently deliver unique and potentially useful material for publicity, you're well on your way to becoming a professional photographer.

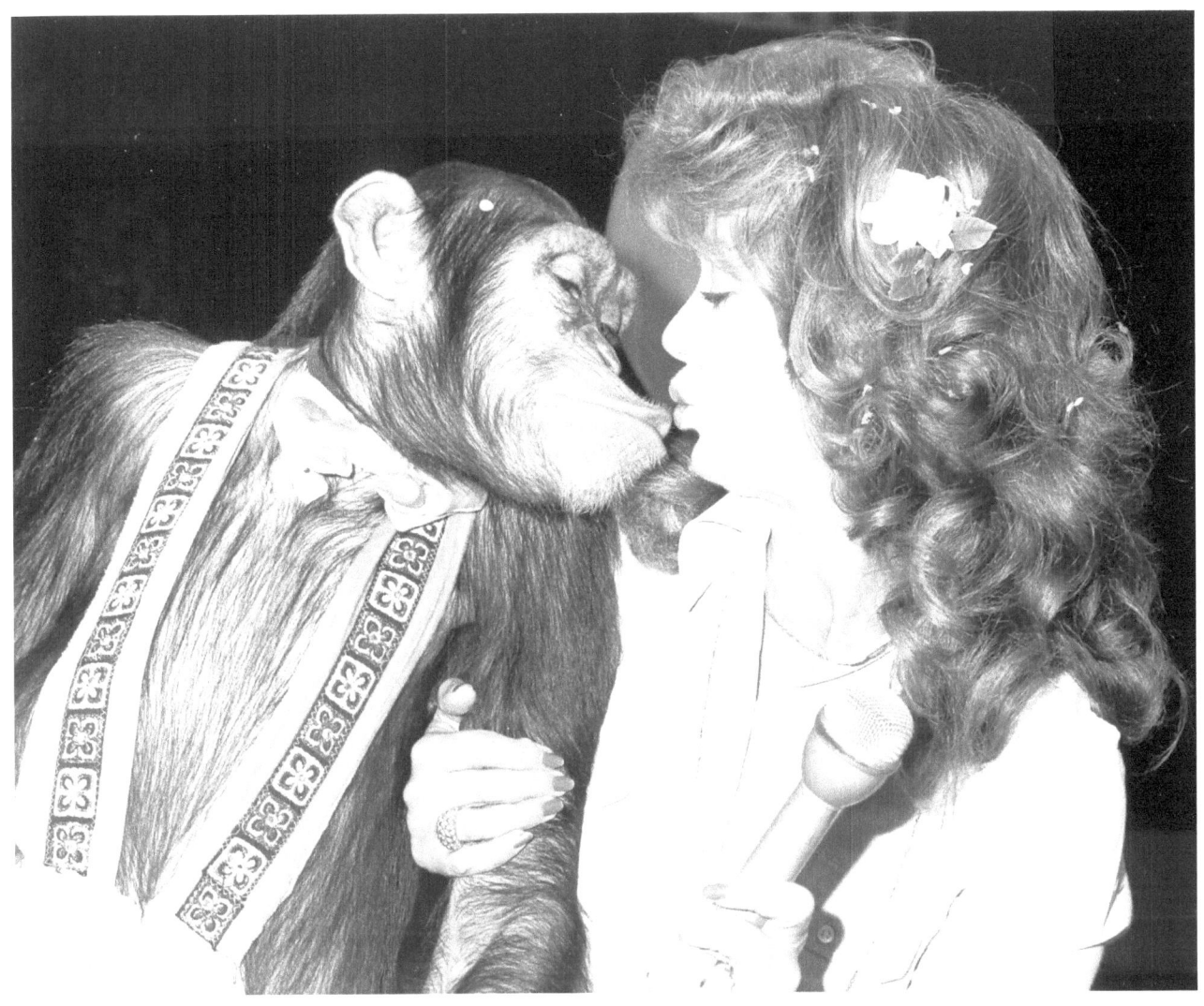

"Monkey business" on-set.

Do you really think the presenter wanted this kiss? It's doubtful. Again, use your skill of being ready and "quick on the draw," at least to make it appear that way.

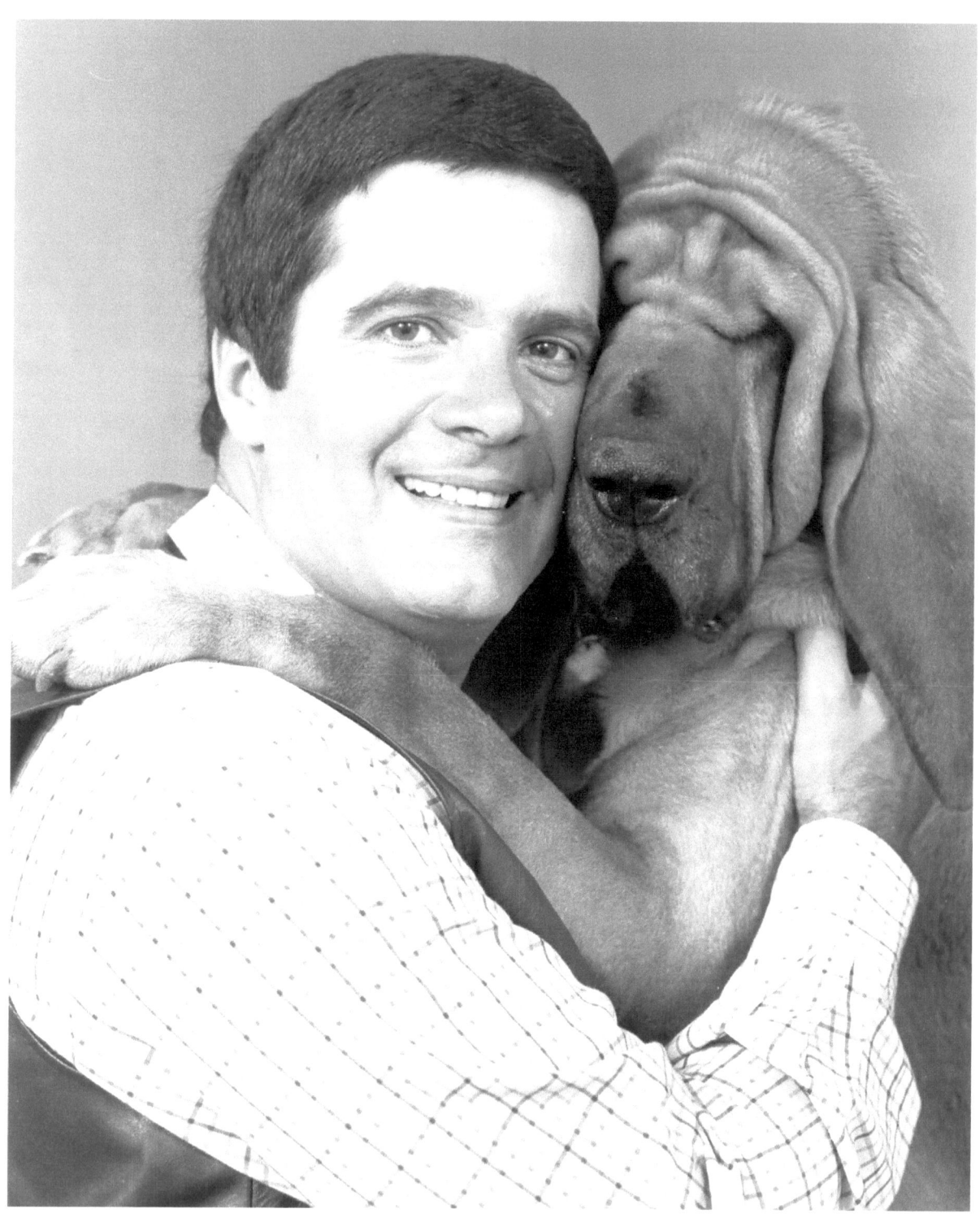

A good example of a publicity shot.

Simon Townsend and Woodrow from the multi award-winning, trend-setting children's show *Simon Townsend's Wonder World*.

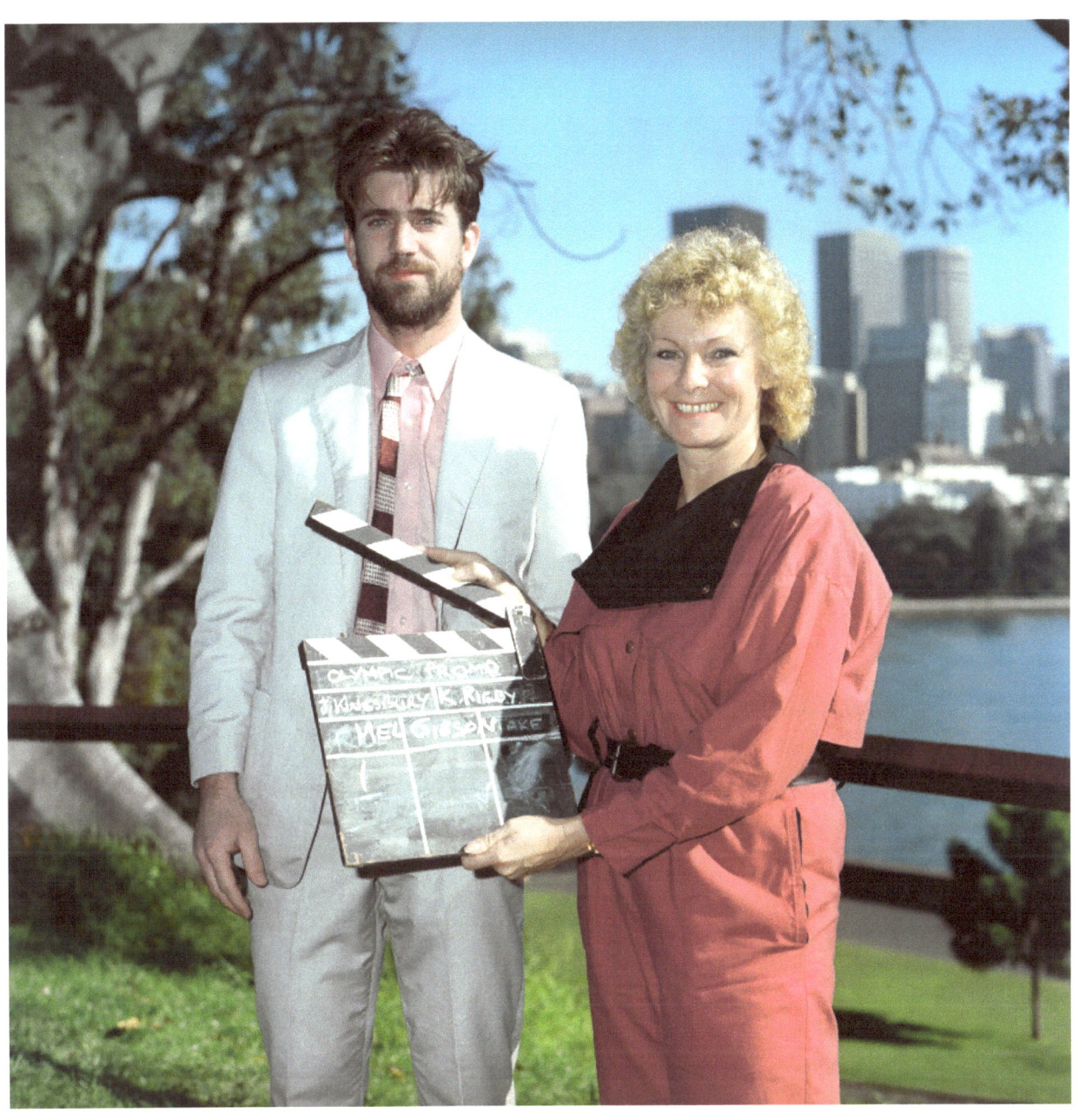

Have a closer look at the young man on the left. Guess who?

If you're given an assignment to go out and grab snaps of someone, do it with as much enthusiasm and professionalism as you would anything else. It doesn't matter if you haven't heard of them, vaguely heard of them or they're in the media and are clearly "on the rise." Do your job, or lose it!

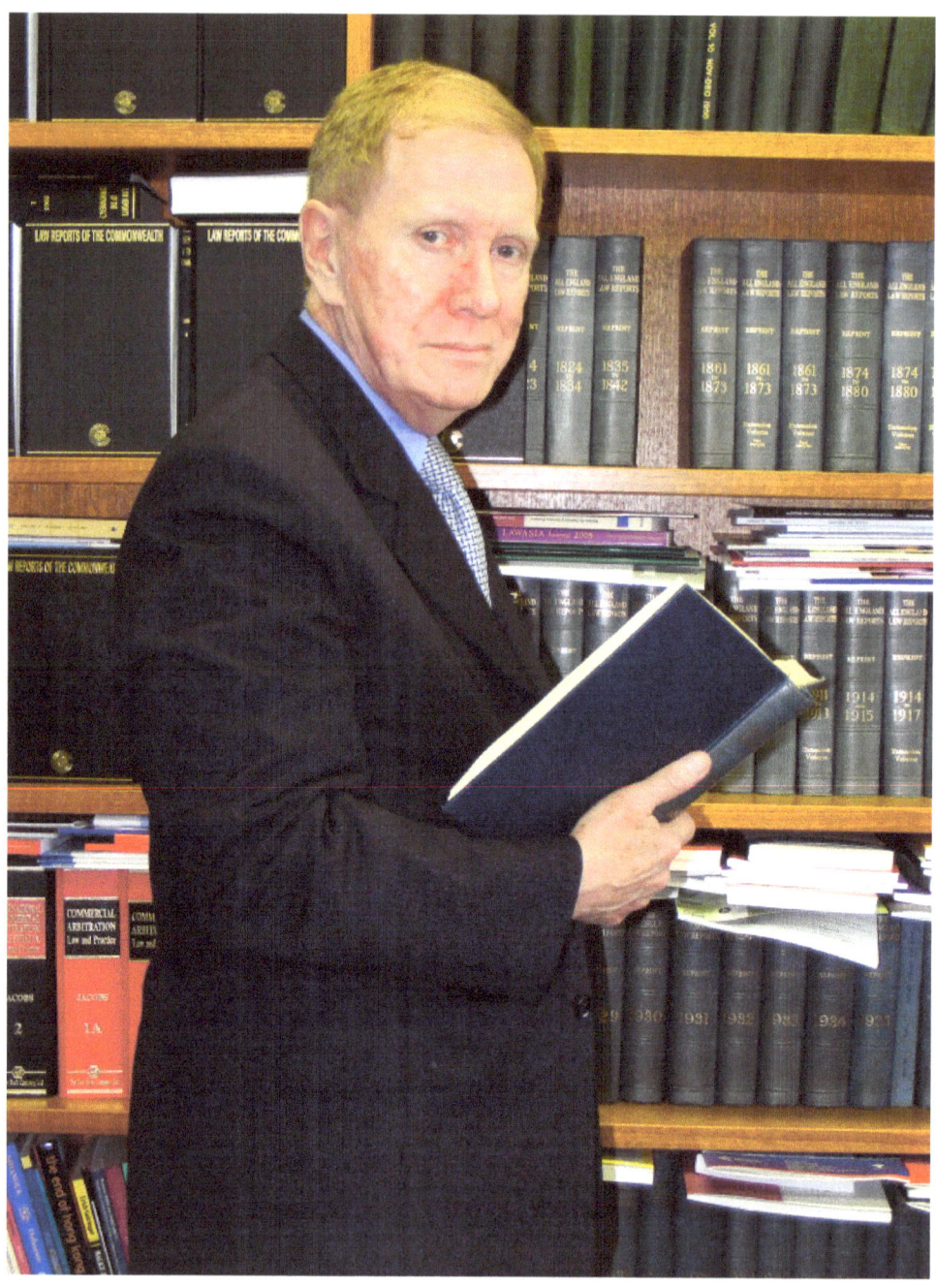

The Hon. Justice Michael Kirby A.C. C.M.G.

Do you think people such as world-renowned judges of the highest courts are always such stoic figures? Most of the time, we only ever catch a glimpse of such people in courts, in snippets in the paper or on TV, and almost never read their important judgments in their entirety. Never assume anything. You may be surprised. Men such as The Hon. Justice Michael Kirby seem to defy explanation, while at the same time displaying obvious great character, warmth and humor.

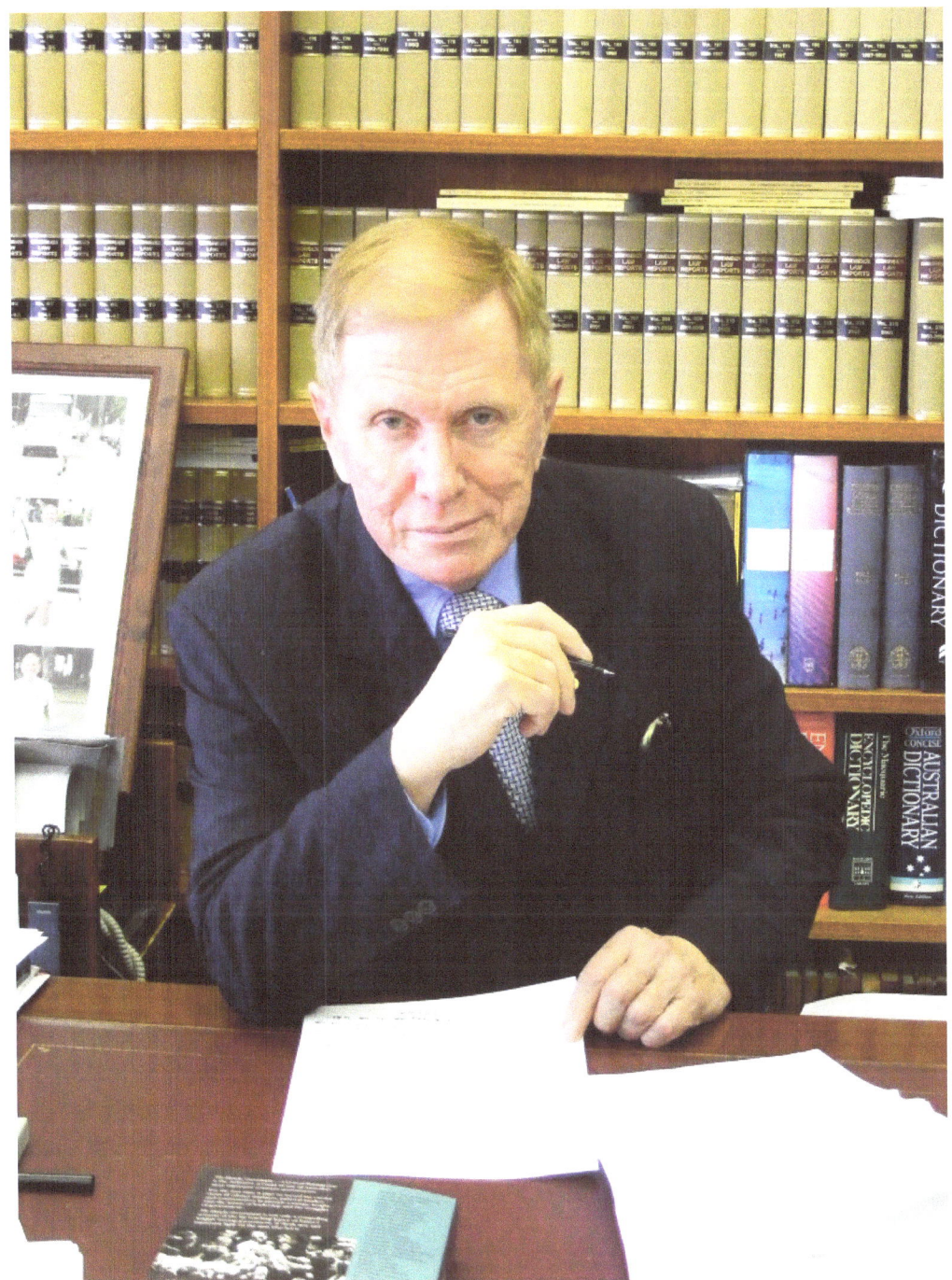

If you're nervous, just start your shoot and "let it flow," but don't snap away saying nothing. Don't be afraid to ask questions beforehand if your subject has an assistant, for example. And if the person you are shooting makes a suggestion, do it. You might never think of it! Keep in mind you might only have five or ten minutes. Be early too; the building they are in may have tight security. Make a habit of always carrying your media card.

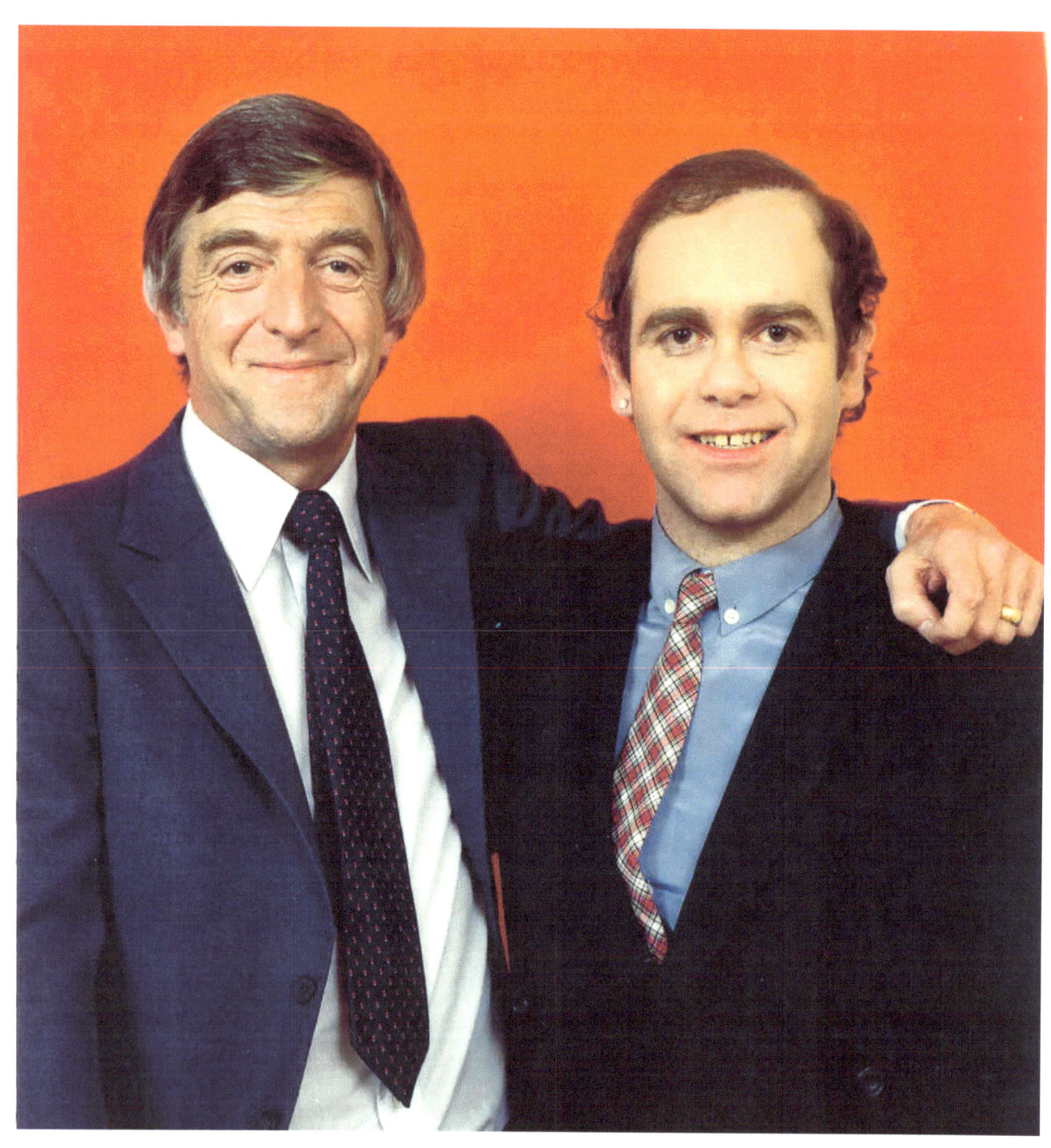

Before they were Knights:

Michael Parkinson and Elton John.

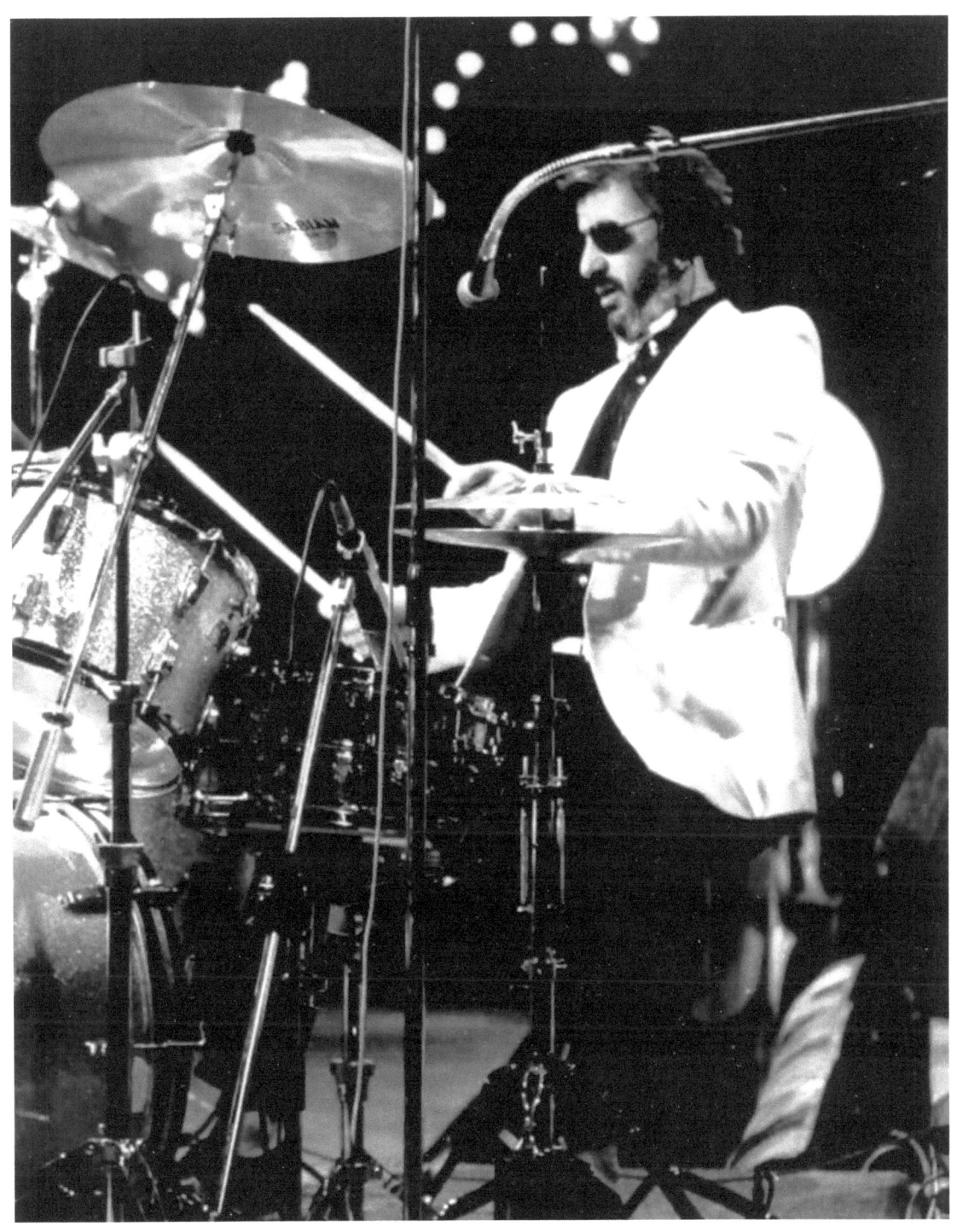

The Beatles drummer Ringo Starr .
For shots like these, by hook or by crook, get up close.

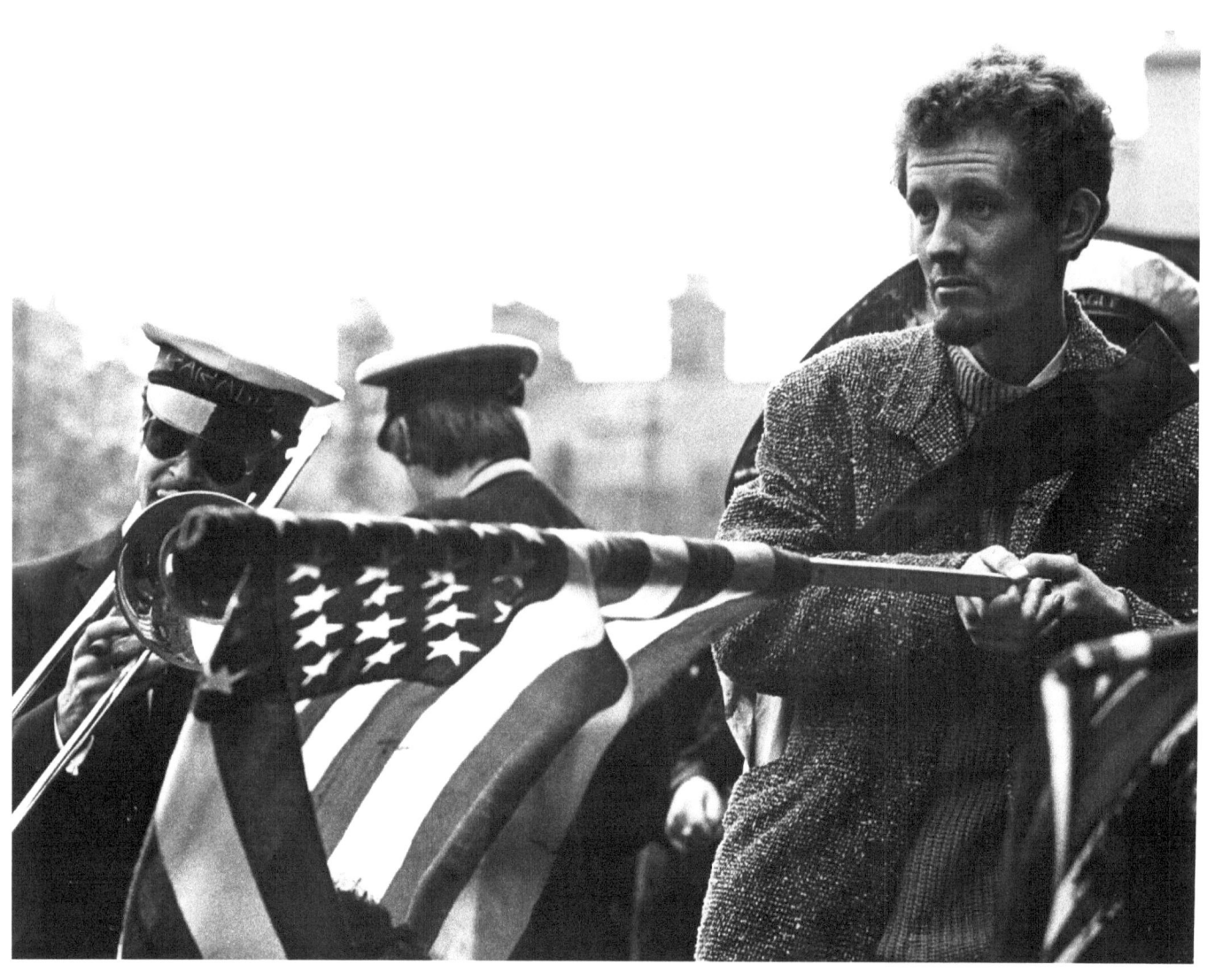

A peacenik at the anti-Vietnam riots in London.

Beware those who burn flags and cause trouble, even if they say they are all about peace. They are often not peaceful at all.

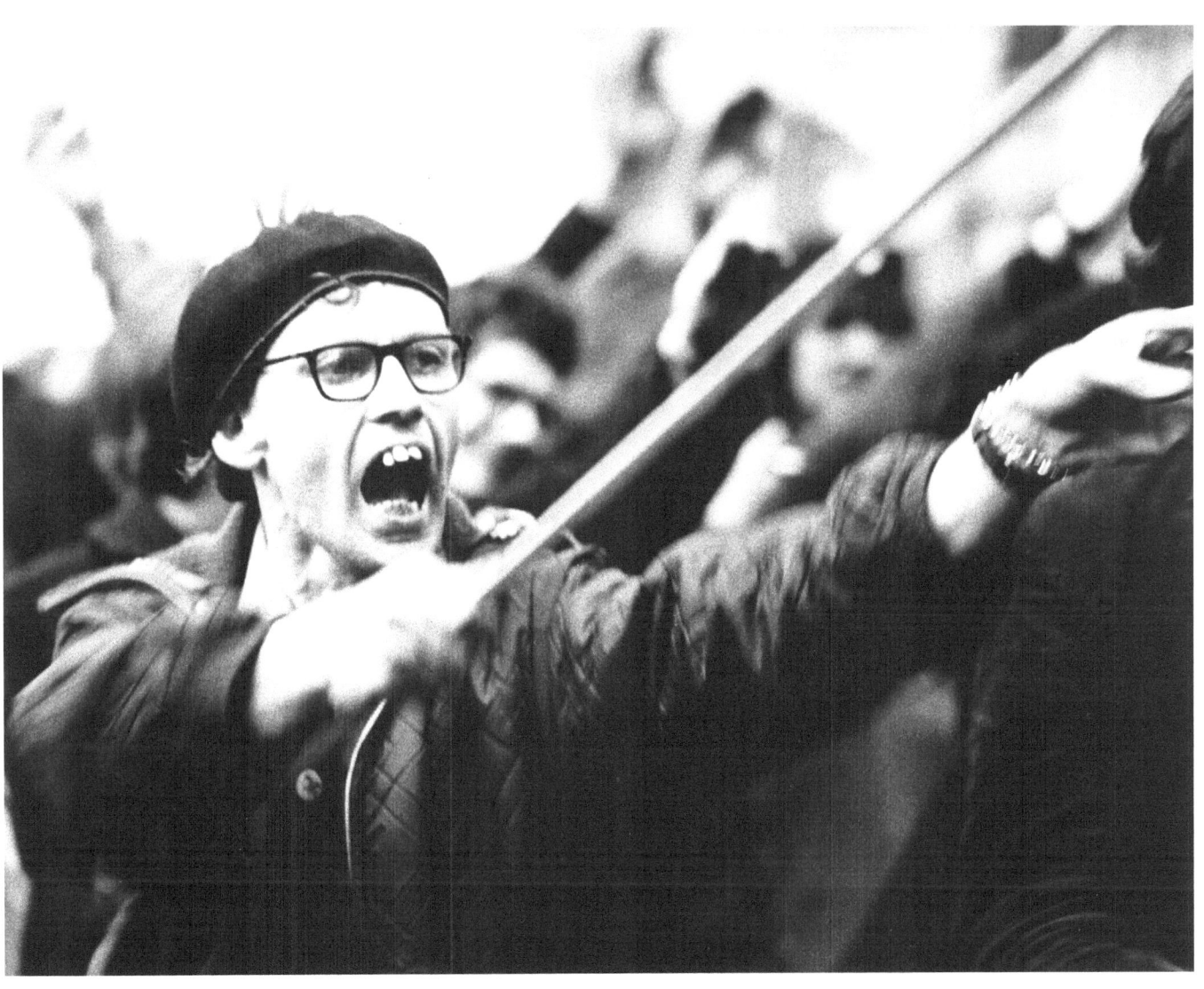

One of the leading rioters at the anti-Vietnam riots in London.

Again, be very careful in protests like these. The rioters showed no care for anyone else, including mounted police, throwing ball bearings under the horses. The crowd also lifted people up, including the author of this book who was shocked to be suddenly carried off. These situations can cause serious injury or even death.

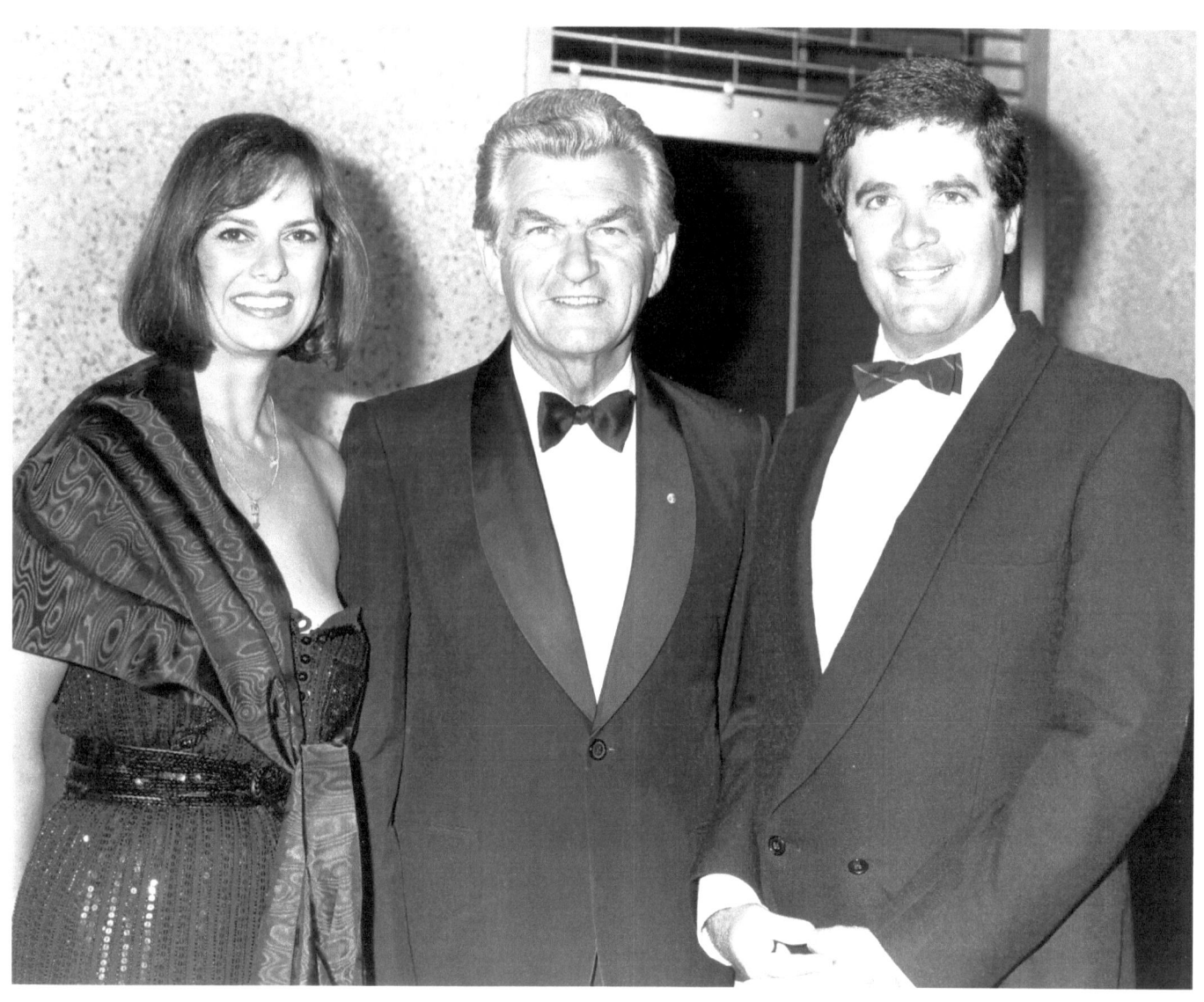

L-R: Mrs Townsend, former Prime Minister of Australia Robert James Lee (Bob) Hawke, A.C., and Mr Townsend.

Bob Hawke was electrifying. Was it his charisma? His conversation and knowledge, having been a Rhodes Scholar, as well as a great Prime Minister? Who knows. In your career you will often come across people who leave you "speechless." It is important to quickly gain your composure and do your job.

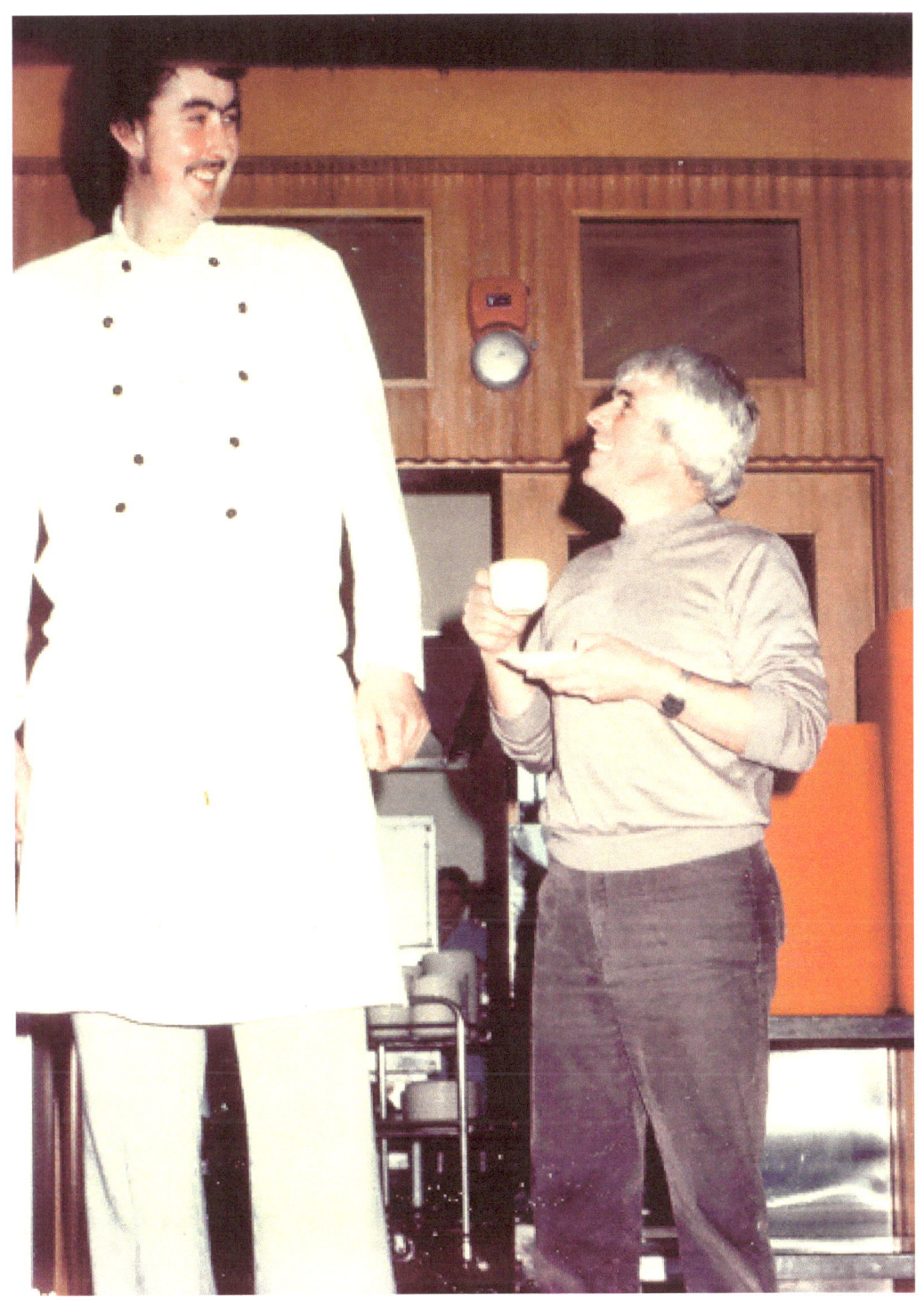

The author of this book having a cup of tea with the (then) tallest man in the world.

Sometimes your "people skills" will come to be very valuable. Overall, this shoot was very sad. He knew he didn't have much time left and was going to die soon.

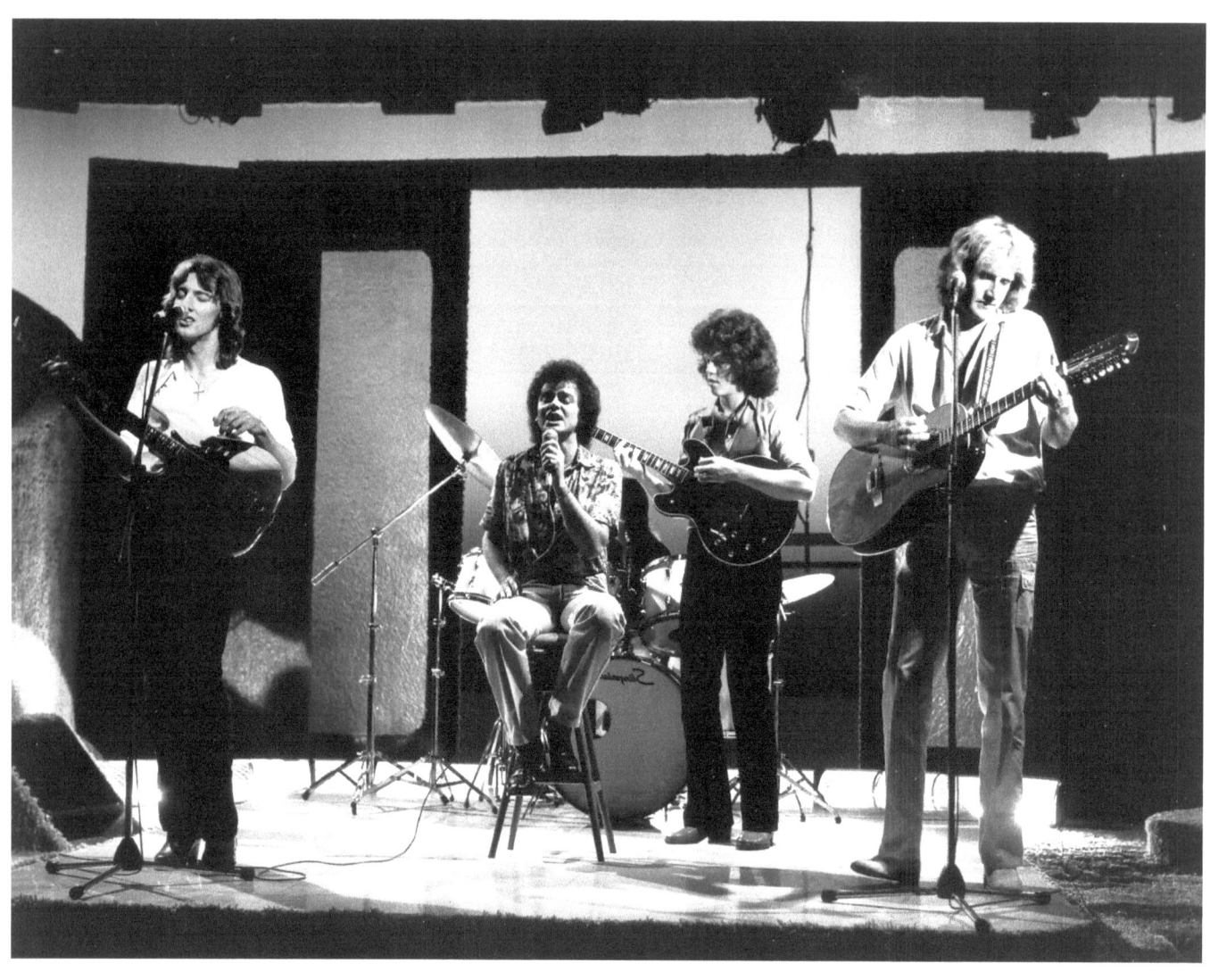

Does anyone recognize this band? Was it Air Supply?

I did so many of these shoots I regret not keeping a log of the shots I did each day. I would highly recommend keeping a shot diary, or something of that nature.

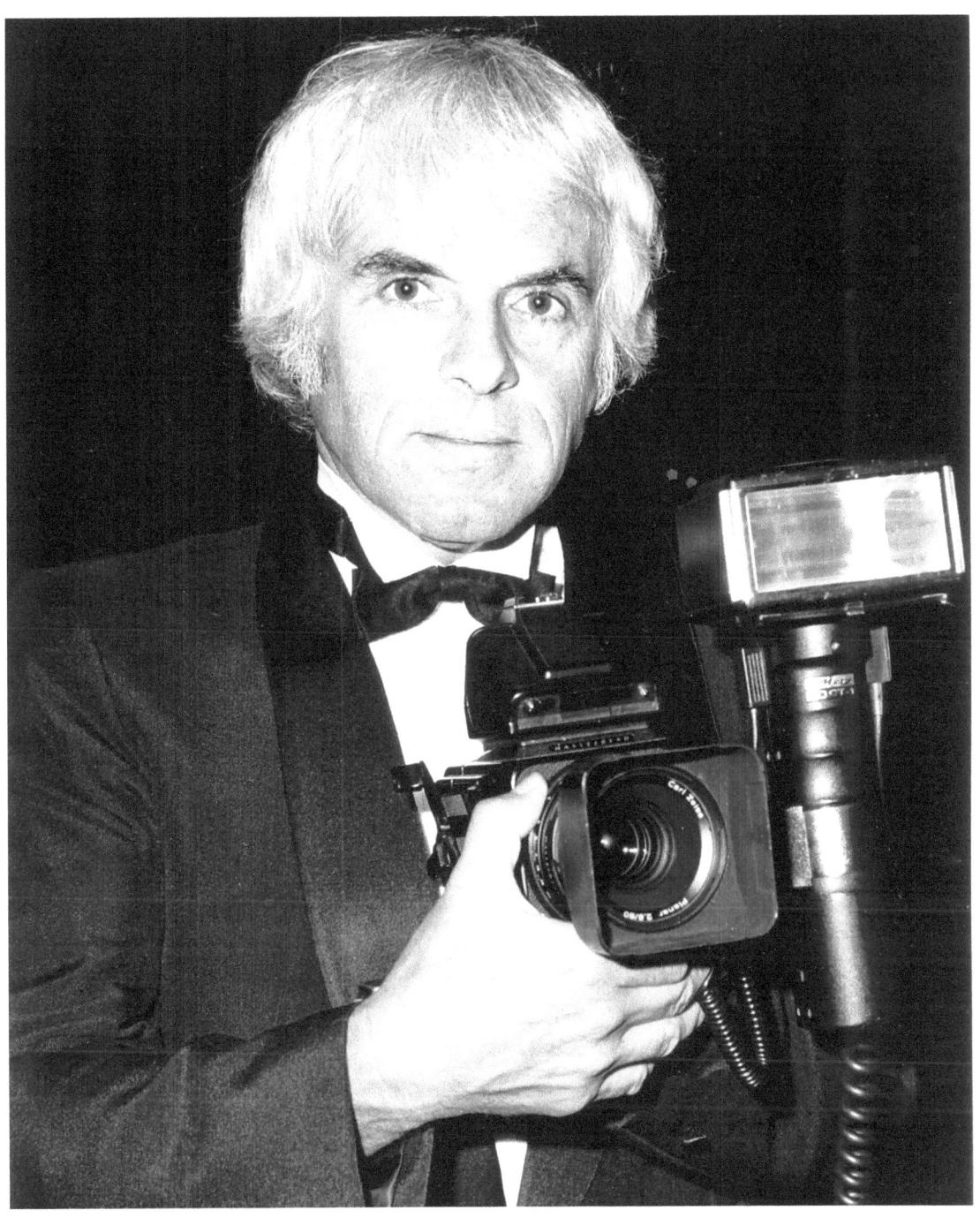

A shot of myself in my professional capacity at a function.

When attending functions in your professional capacity, never be tempted to drink or take anything else you might be offered. You can never afford what the consequences might be. If you have to, make up a story and stick to it (e.g. you've got ulcers, anything) or make up something plausible on the fly. This way you can avoid any offer of drinks or anything else while not offending those who offer you something.

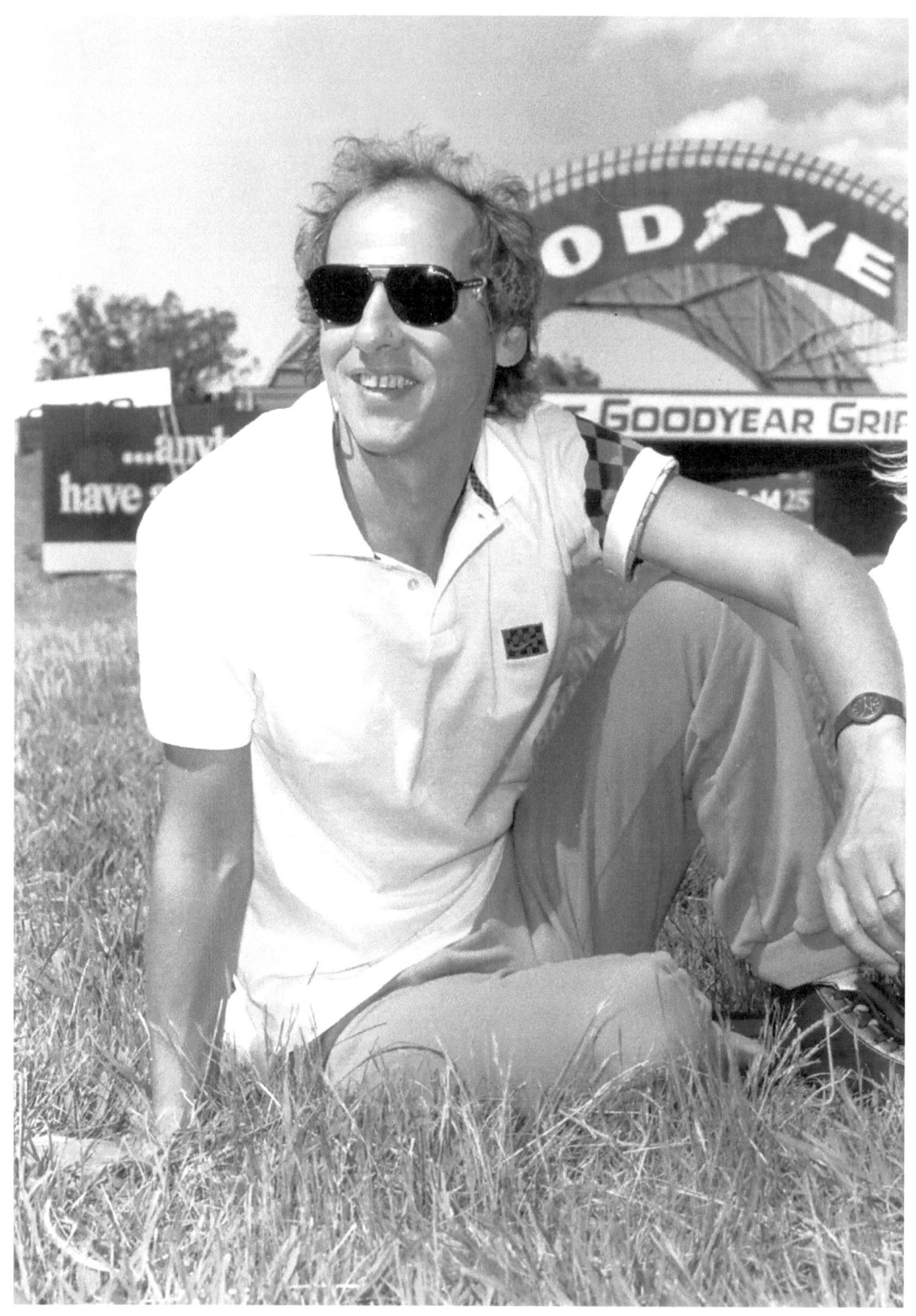

Mark Knopfler of the band Dire Straits.

I asked politely if he wouldn't mind me taking a shot. He just looked up and smiled, and was very pleasant (I wondered if he was tired of all the shoots). Don't wait, take that shot!

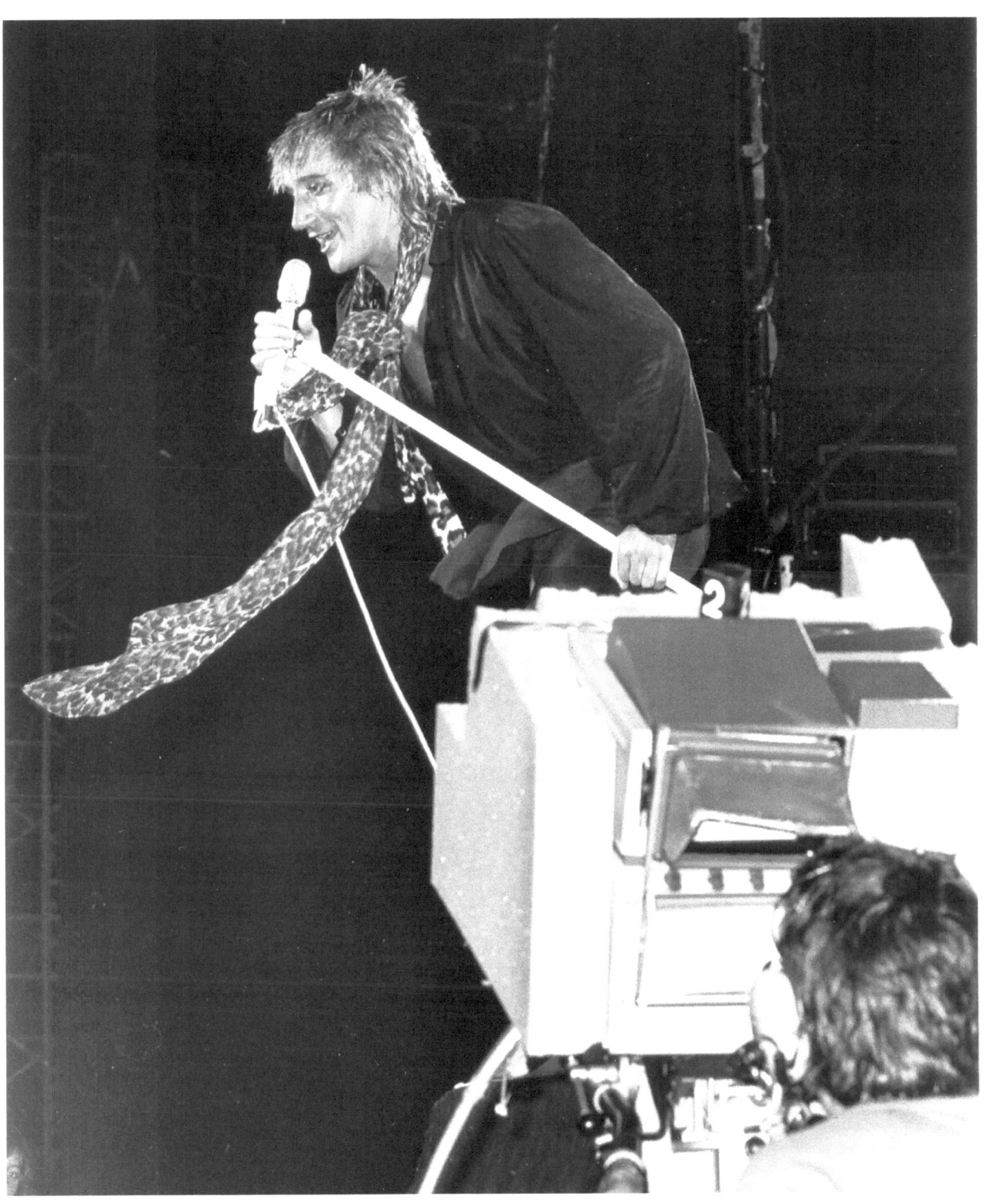

Rod Stewart making the crowd go wild!

This is also another example of getting up close "by hook or by crook." Slip in quickly and get those shots!

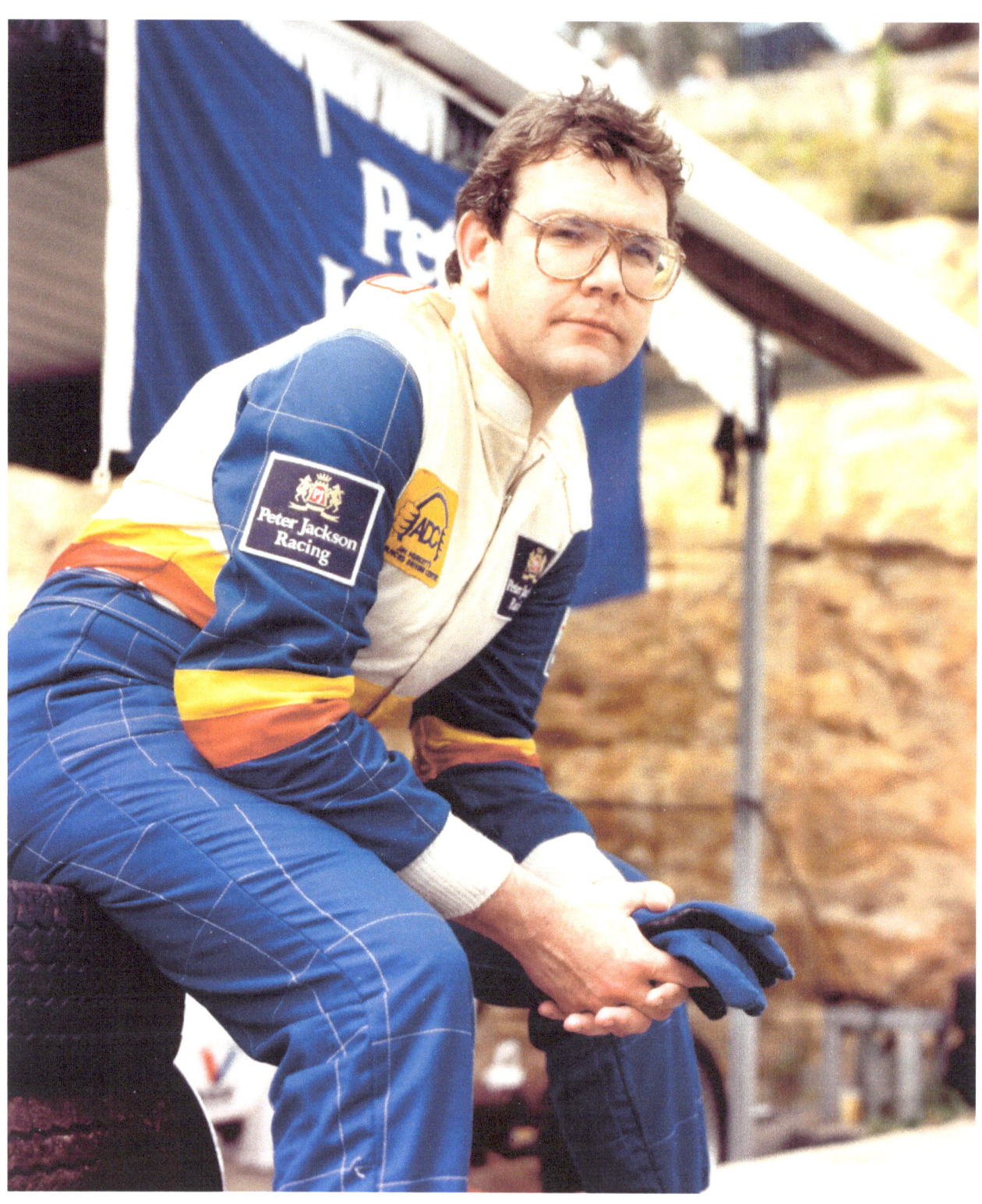

Gordon Elliott wasn't "just" an Australian then American television personality.

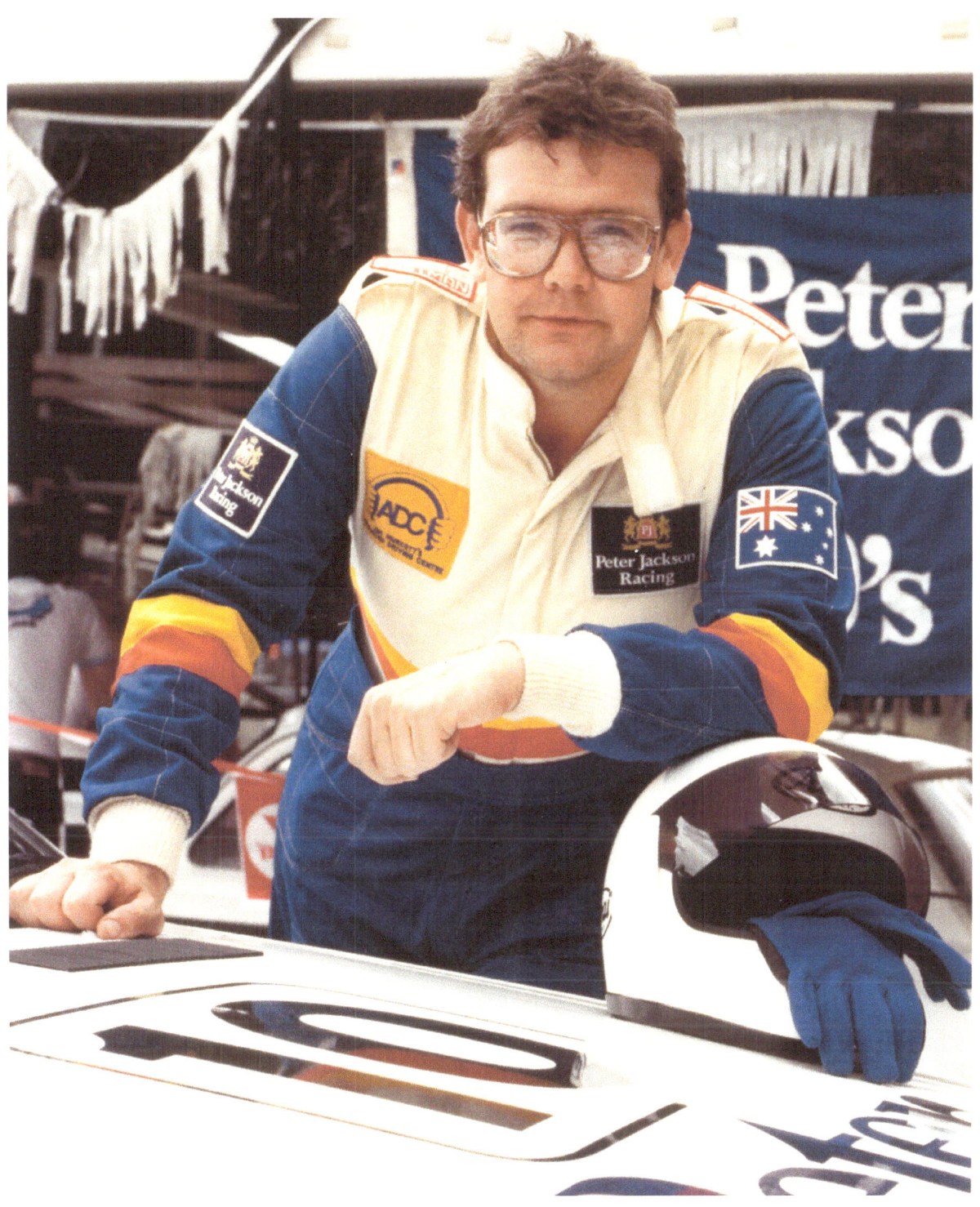

Gordon Elliott indulging in one of his passions, racing.

I remember Gordon Elliott not just as an interesting and talented man, but also for his April Fool's Day pranks at Network Ten, Sydney. I still laugh at them to this day.

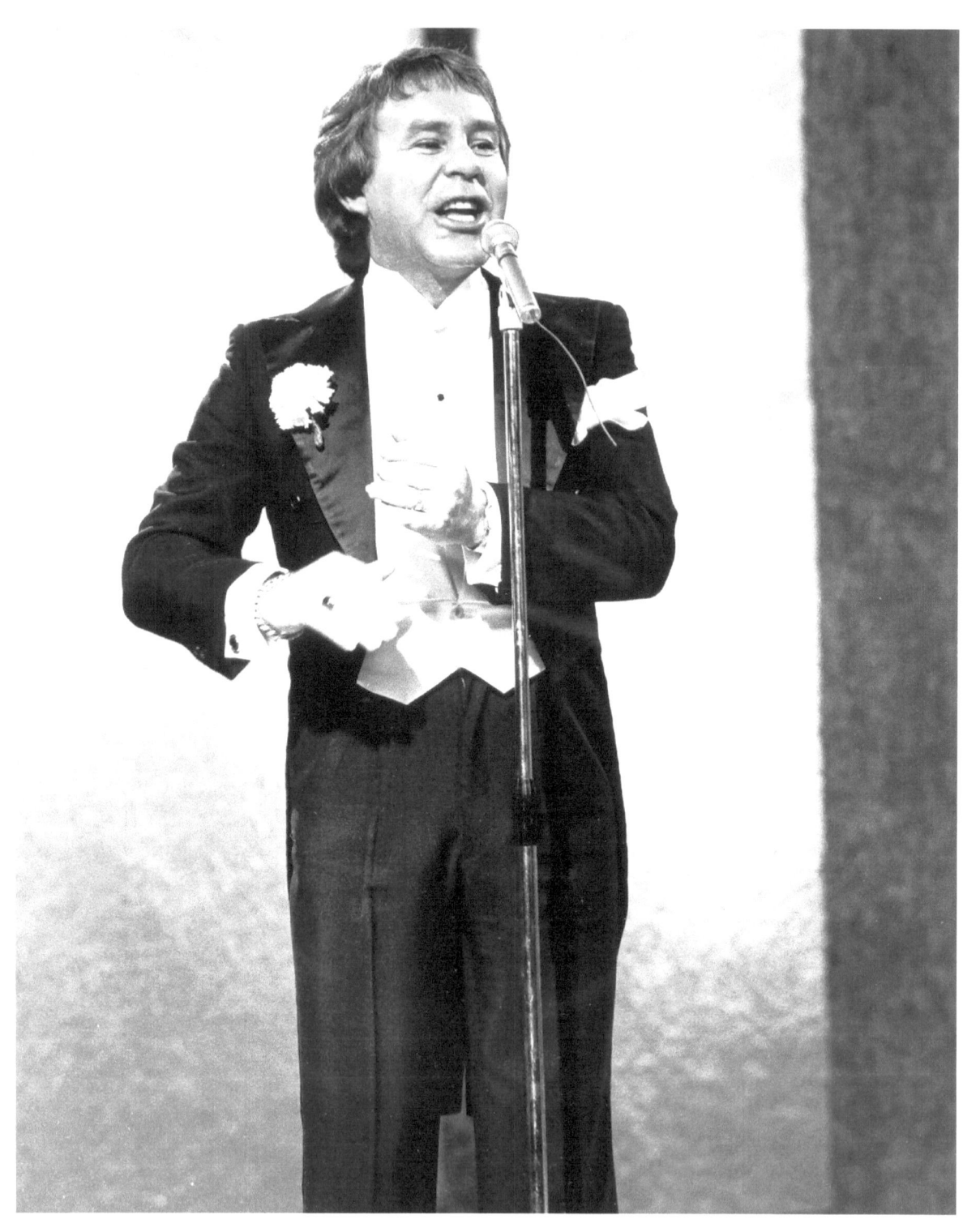

Johnny O'Keefe.

One of the last shots of O'Keefe performing before he passed away.

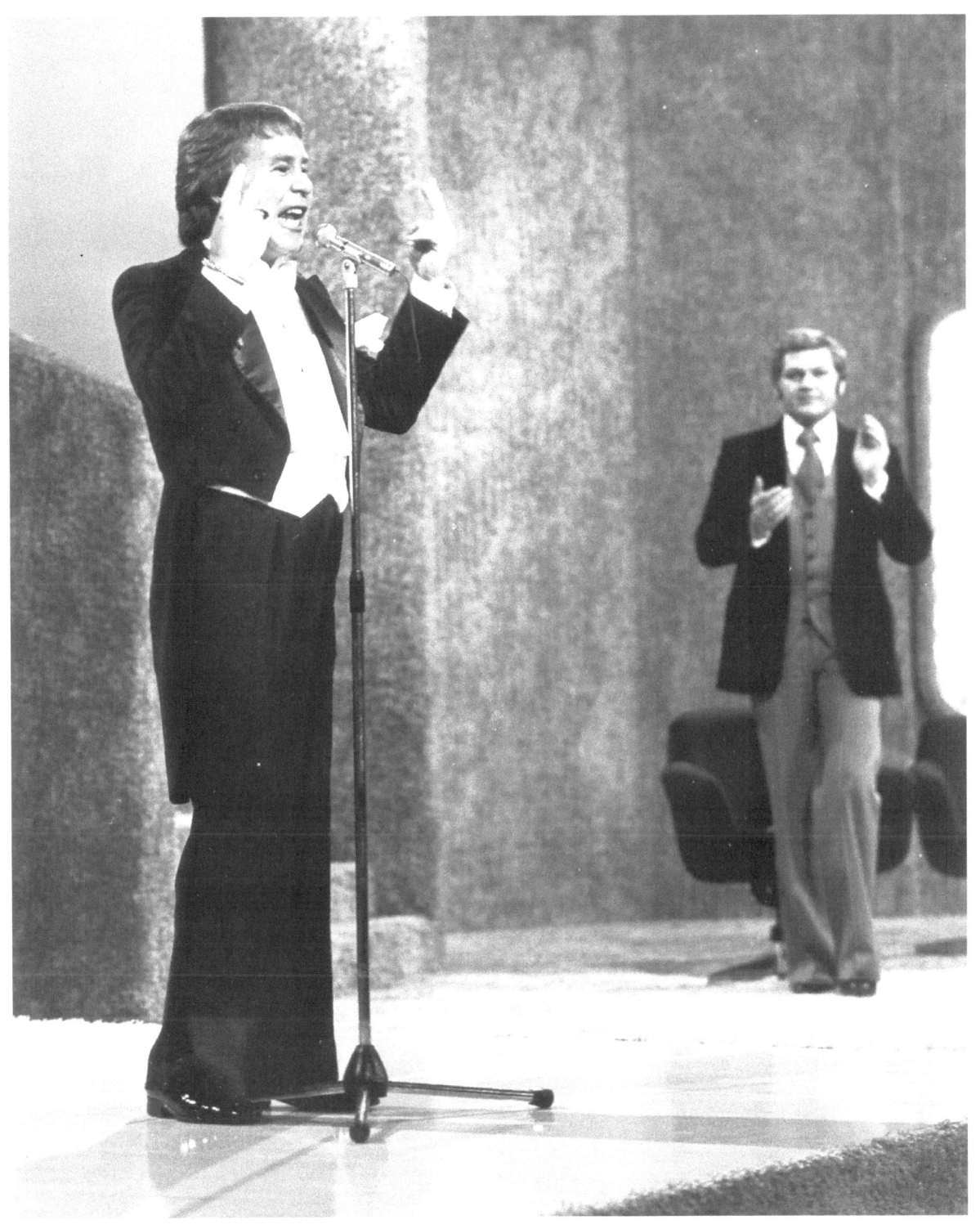

Johnny O'Keefe certainly knew how to perform!

One of the many interesting publicity shots I've done.
In this case, for Radio 2SM, Sydney.

26 *Professional Photography: A Practical Guide*

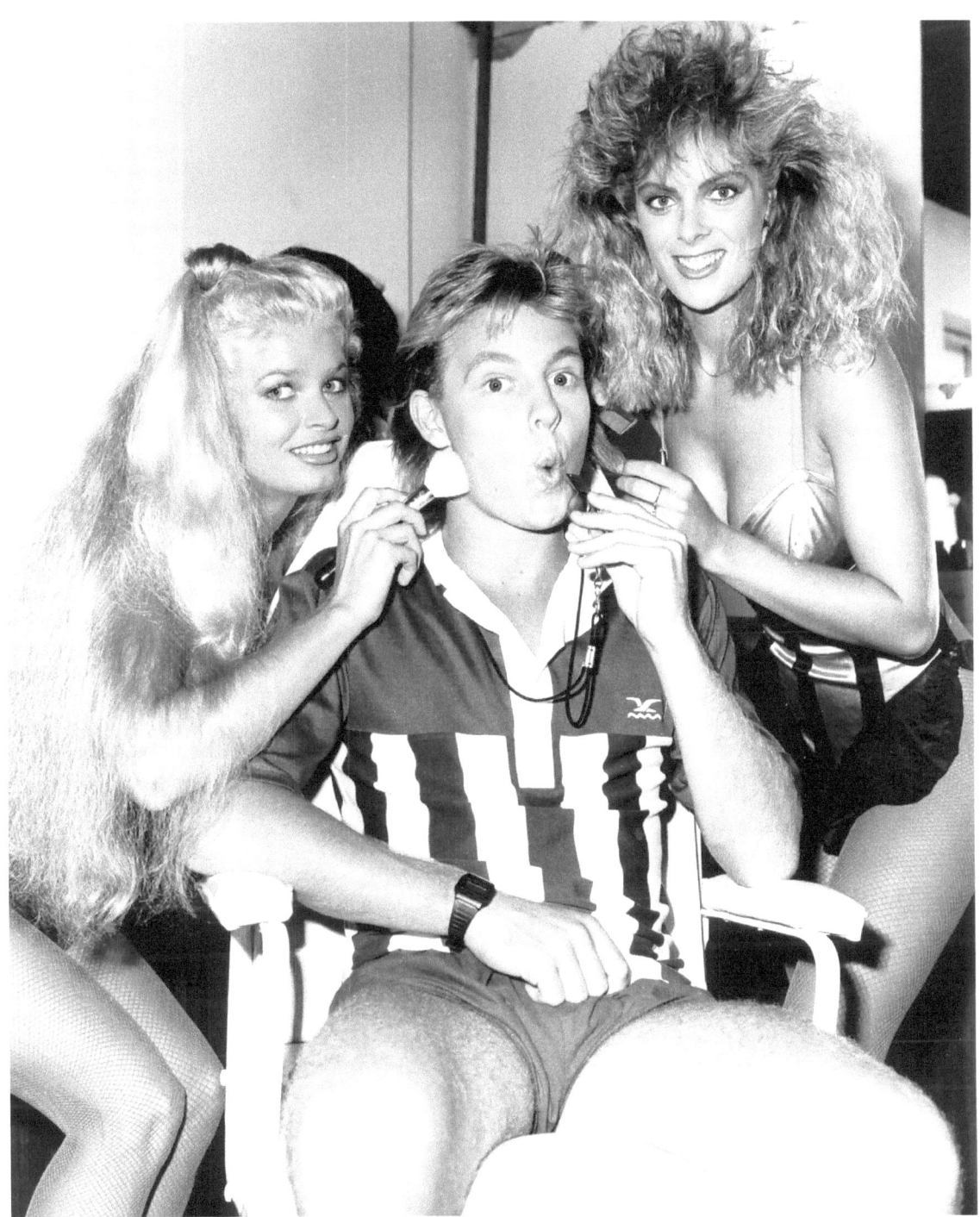

A talented young man by the name of Jason Donovan, before he was well known. His father asked me to do a portfolio and I happily obliged.

Always do favors. You may end up being on the receiving end of them yourself. A pleasant young man once asked me about photography, and I happily taught him. Later, I was stunned to learn the young man was a relative of the Sultan of Brunei!

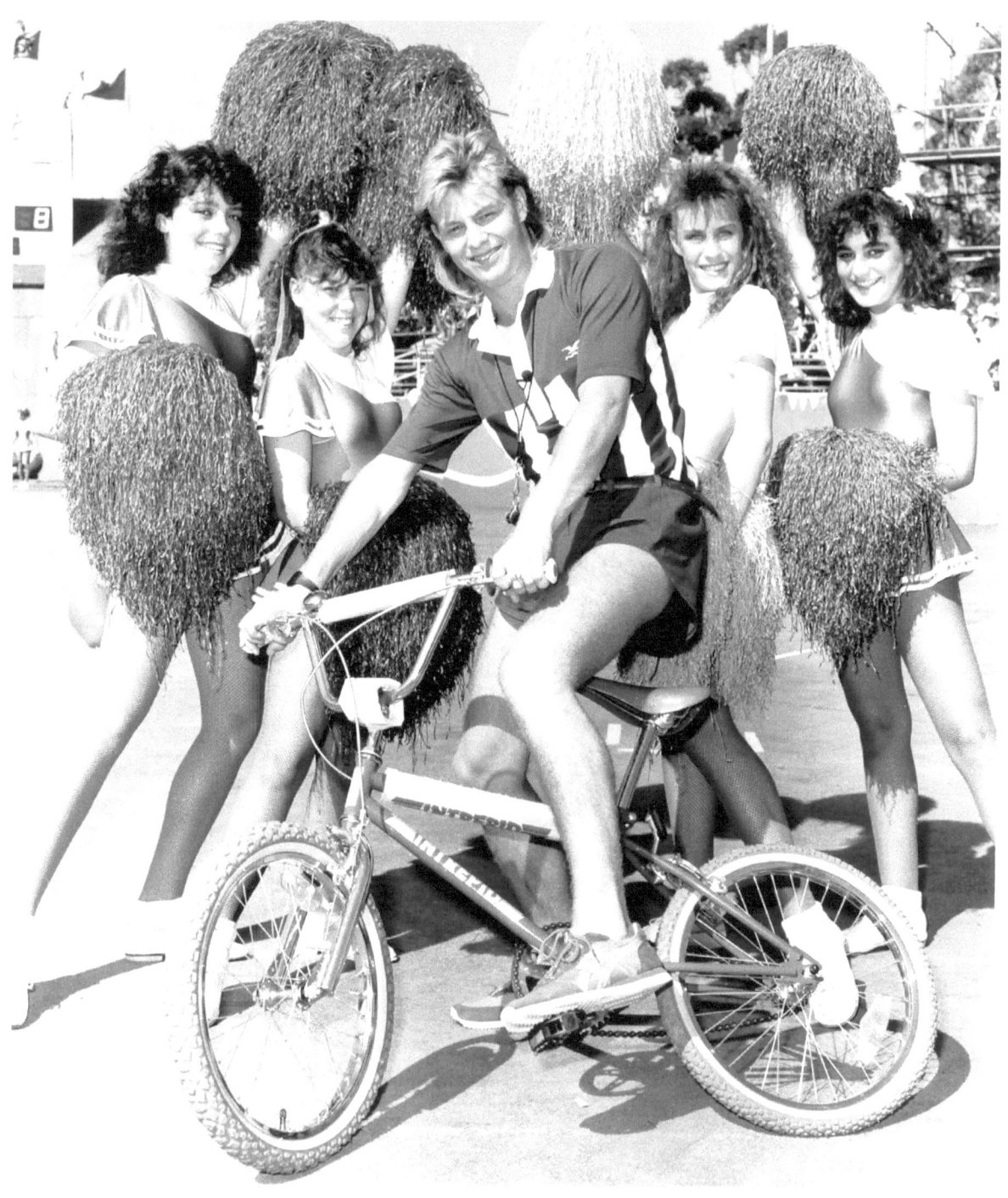

Jason Donovan and cheerleaders.

When doing a portfolio for someone at their request, or the request of someone else or your employer, try to keep some shots (with their permission). I regret not keeping any of the very first portfolio shots of a teenage Kylie Minogue O.B.E. I took before she became the character *Charlene* in Network Ten's *Neighbours*.

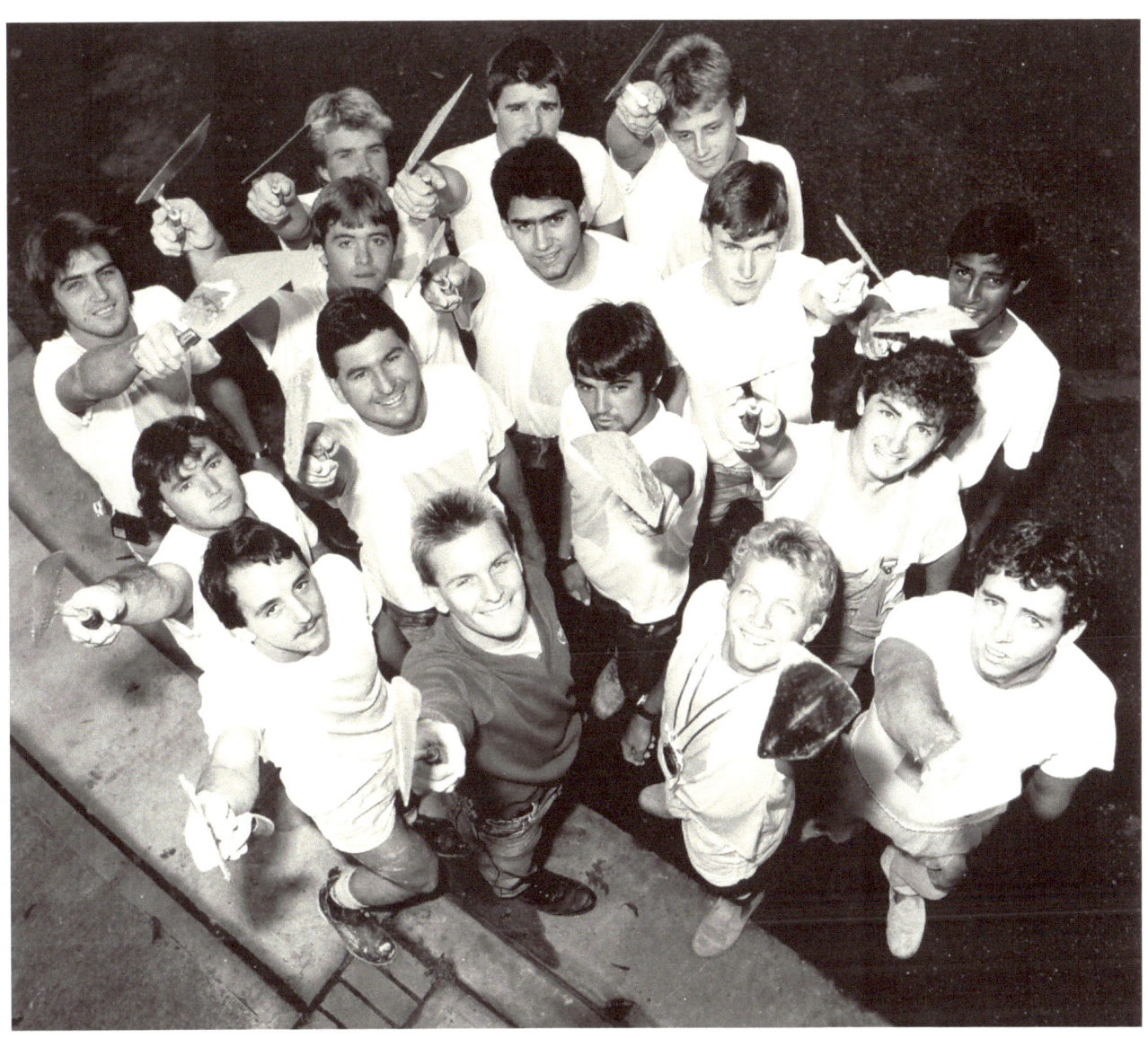

A crew shot.

Always do favors. It's professional behavior and is one of those things that will earn you a good reputation. As I have recently mentioned, you may end up needing a favor yourself some time.

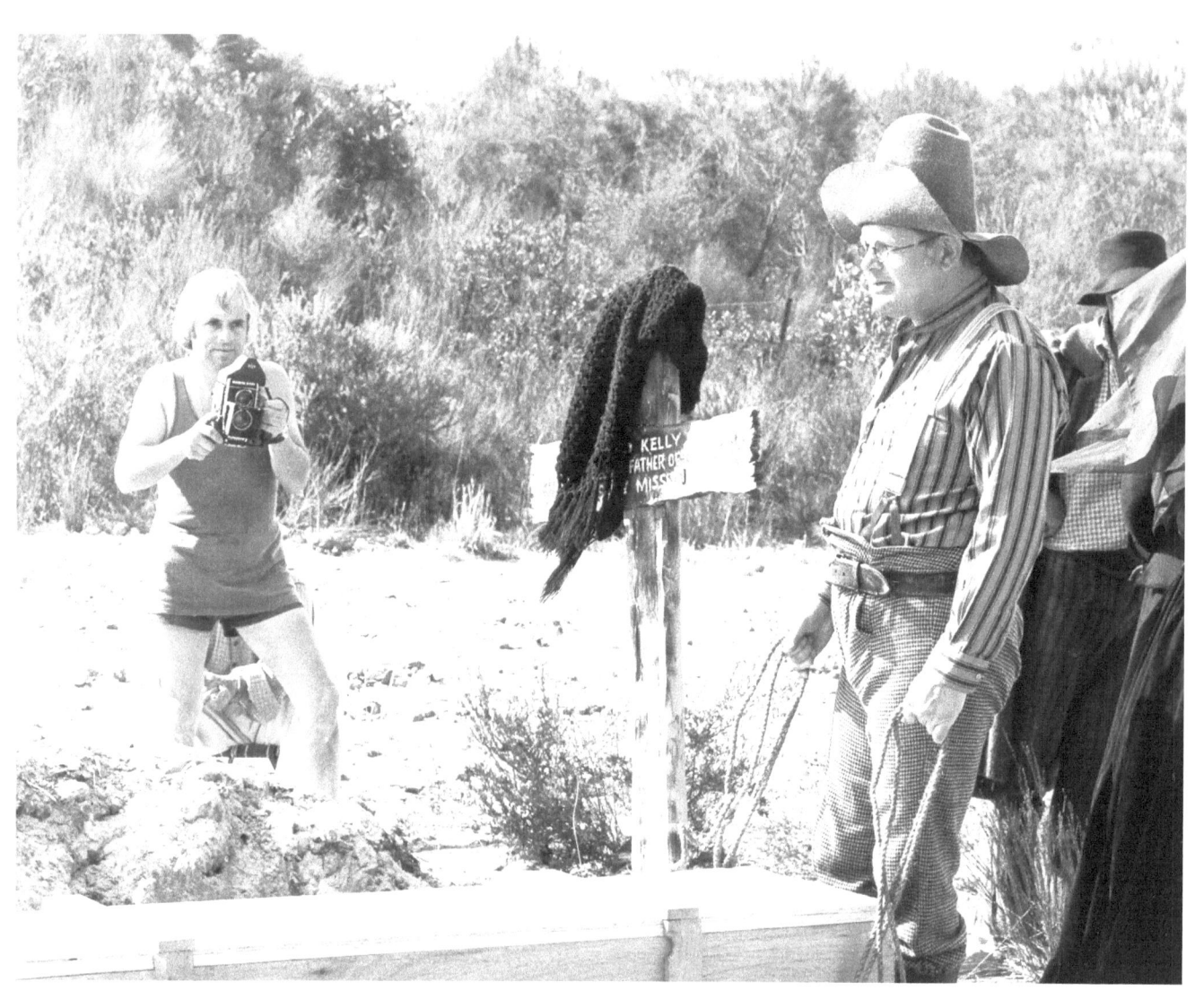

On the set of "Benny Kelly."

Part of your job is to get the shots, then get out the way.

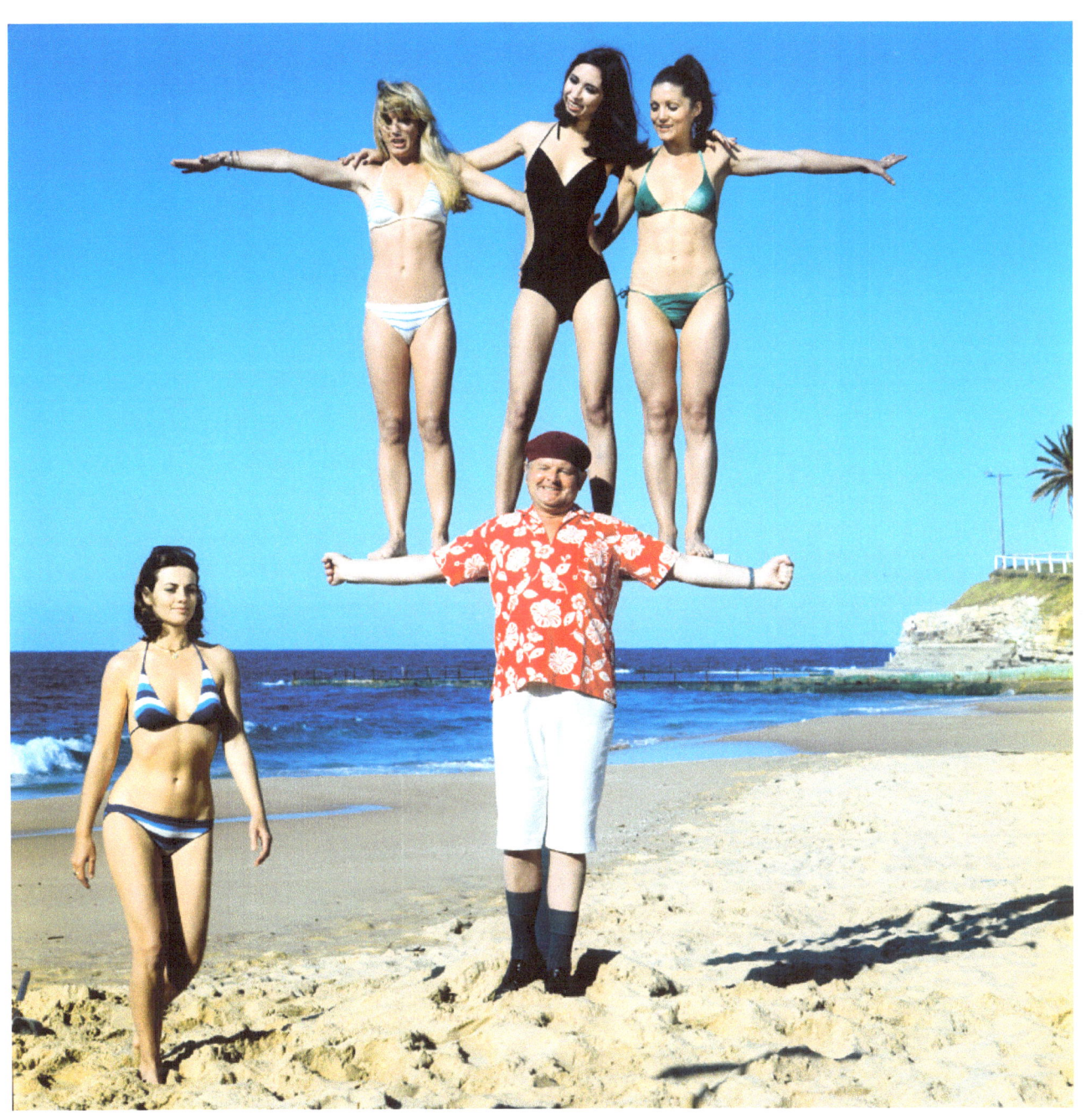

The legendary British comic Benny Hill.

He always loved a gag (even if it was "on him") and was a wonderful person. I'll never forget him.

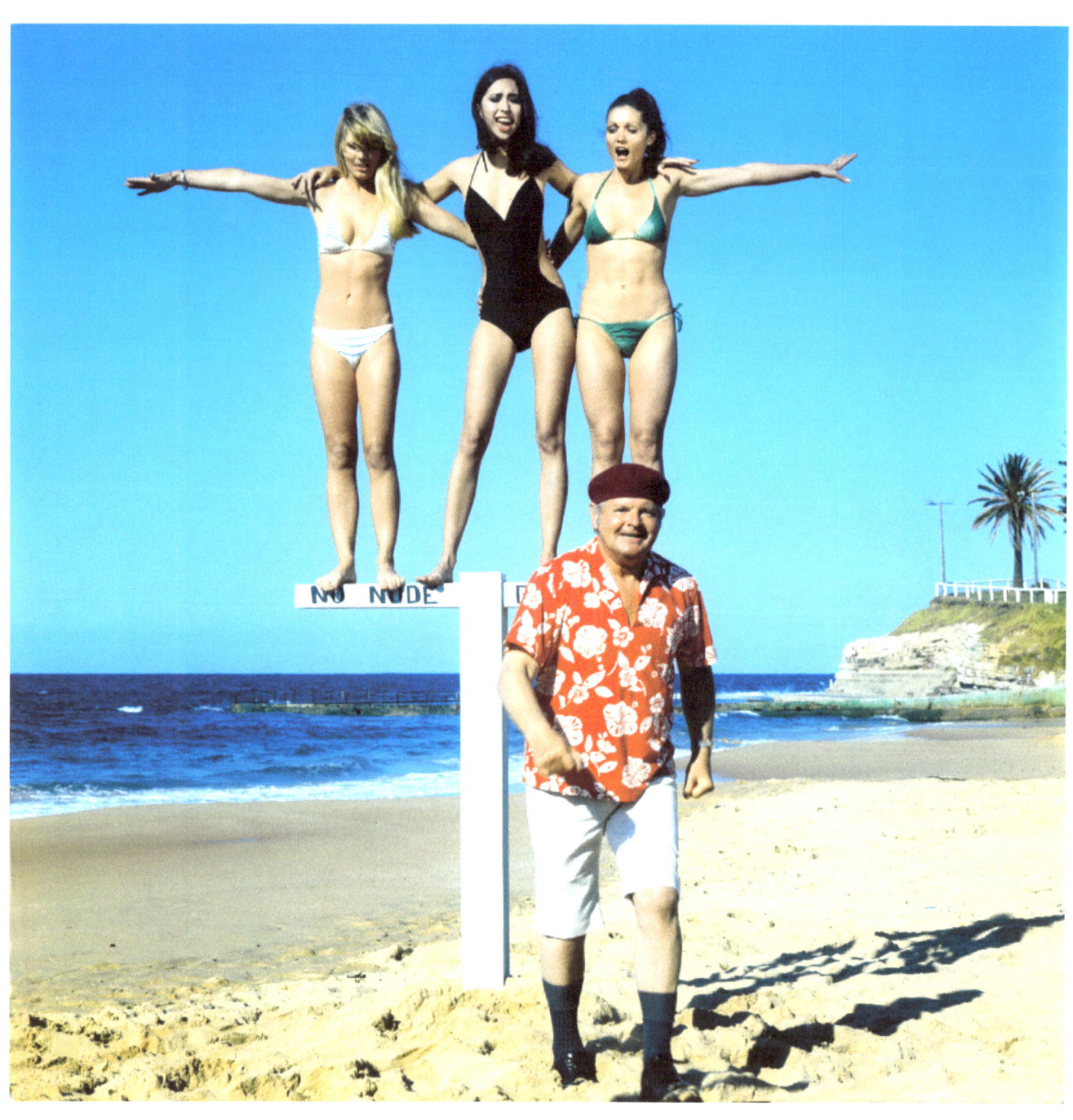

Benny Hill recovering from a good laugh.

Benny Hill prepares for the cameras to roll.

In this case, he rides into town – sort of! He had a knack for getting the most laughs with the least words.

Kerri Anne Kennerly and Leo Sayer.

I have many fond memories of Kerri Anne. She was a great friend. Kerri Anne never ceases to amaze me – she's still going, but with the Nine Network. Anyone remember "You Make Me Feel Like Dancing" and the other hits? Leo is no slouch himself, and is still going too!

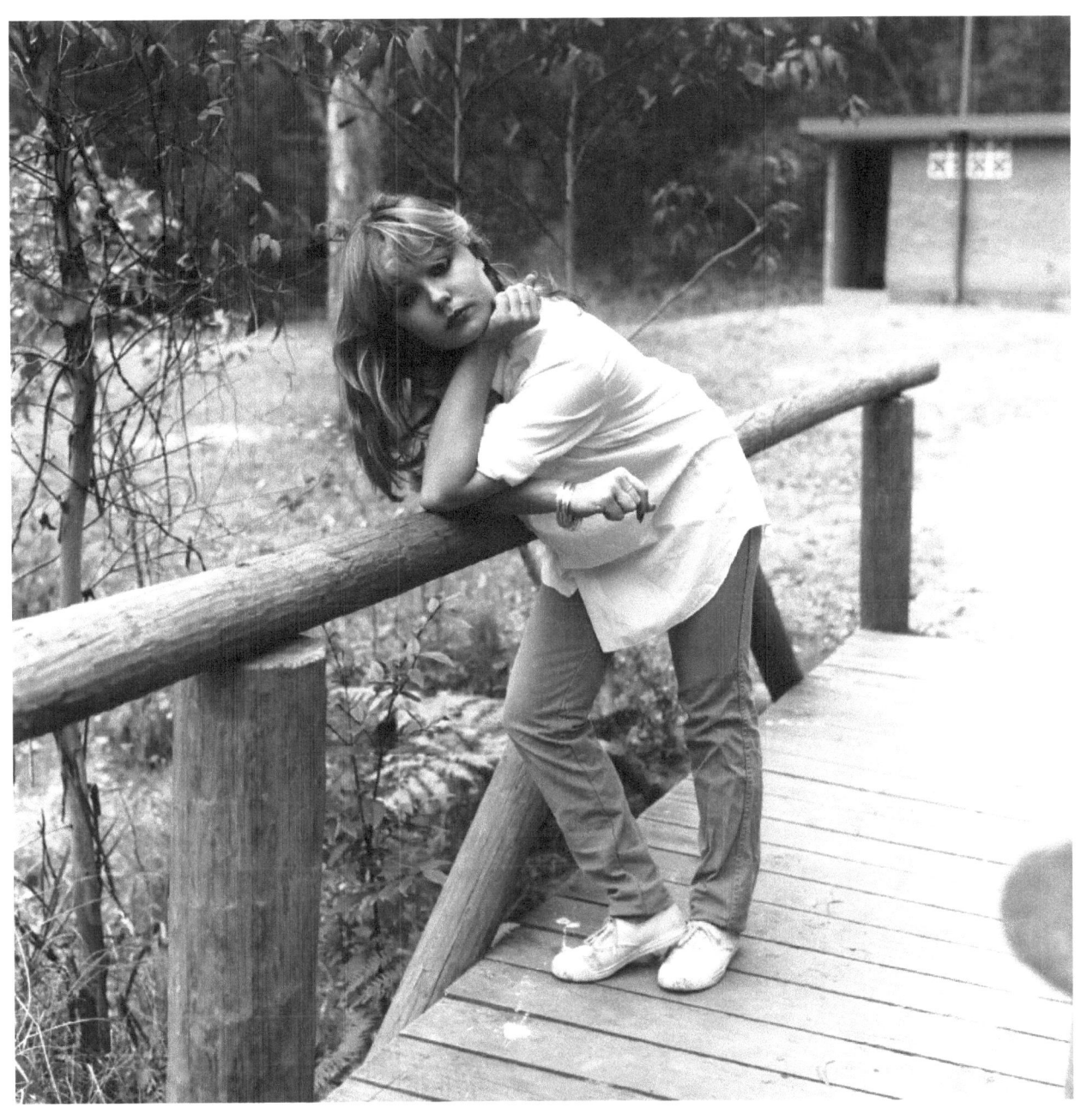

The incredibly talented Arkie Whiteley

Daughter of Archibald prize-winning Australian a rtist Brett Whiteley, A.O.

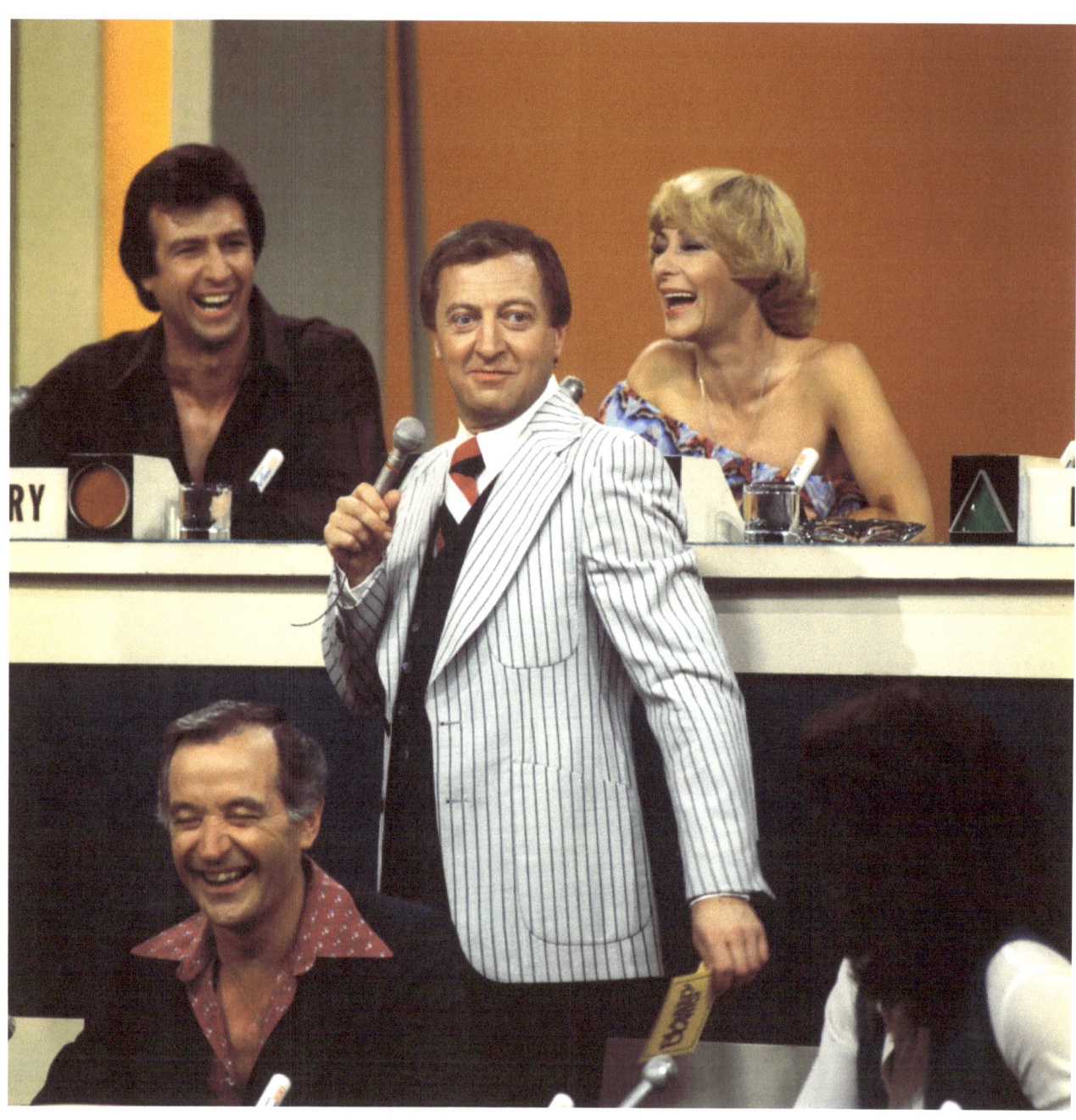

Talented and hilarious, Mr Graham Kennedy, A.O.

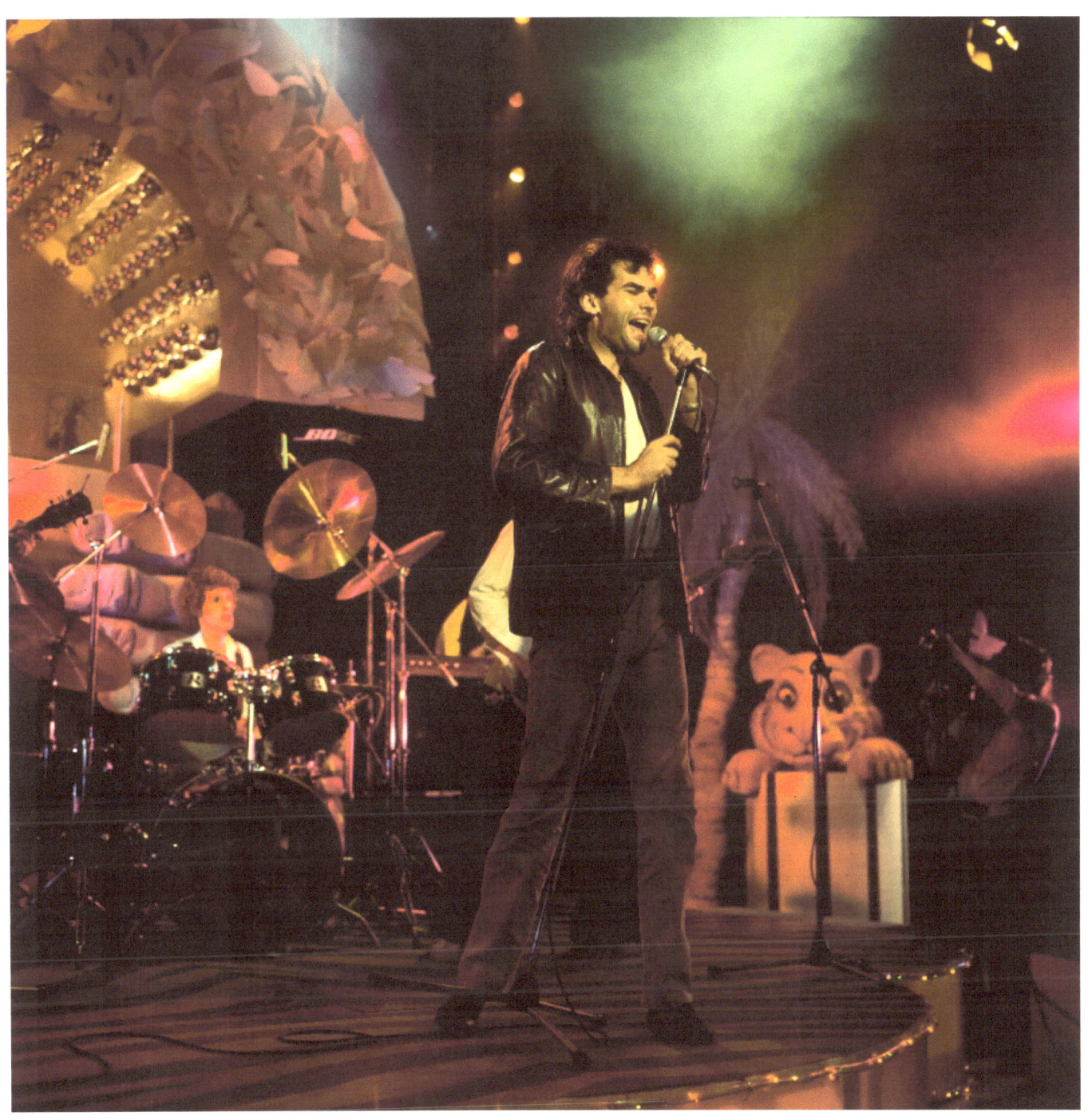

Marc Hunter of Dragon.

Concerts can be exhilarating, amazing experiences. I remember being swept up along with the very pleased crowed as Dragon belted out their hit, "April Sun in Cuba." Whenever I hear it I always remember going for my Hasselblad. With experience, the camera becomes an extension of your arm, and you will find yourself taking great shots automatically. You should aim for this capability.

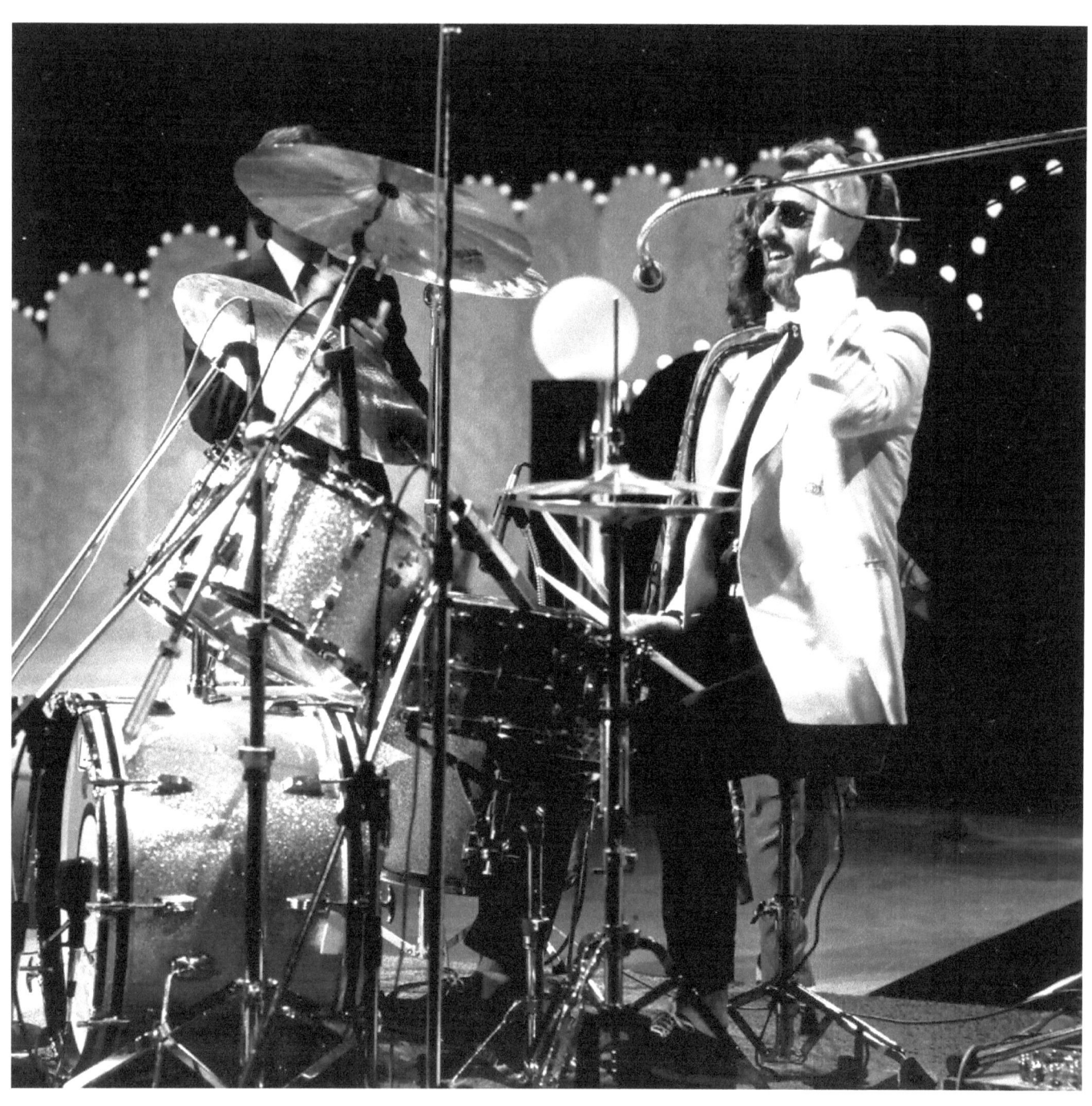

Ringo Starr.

"Capturing the moment" is an important skill you can never be too good at.

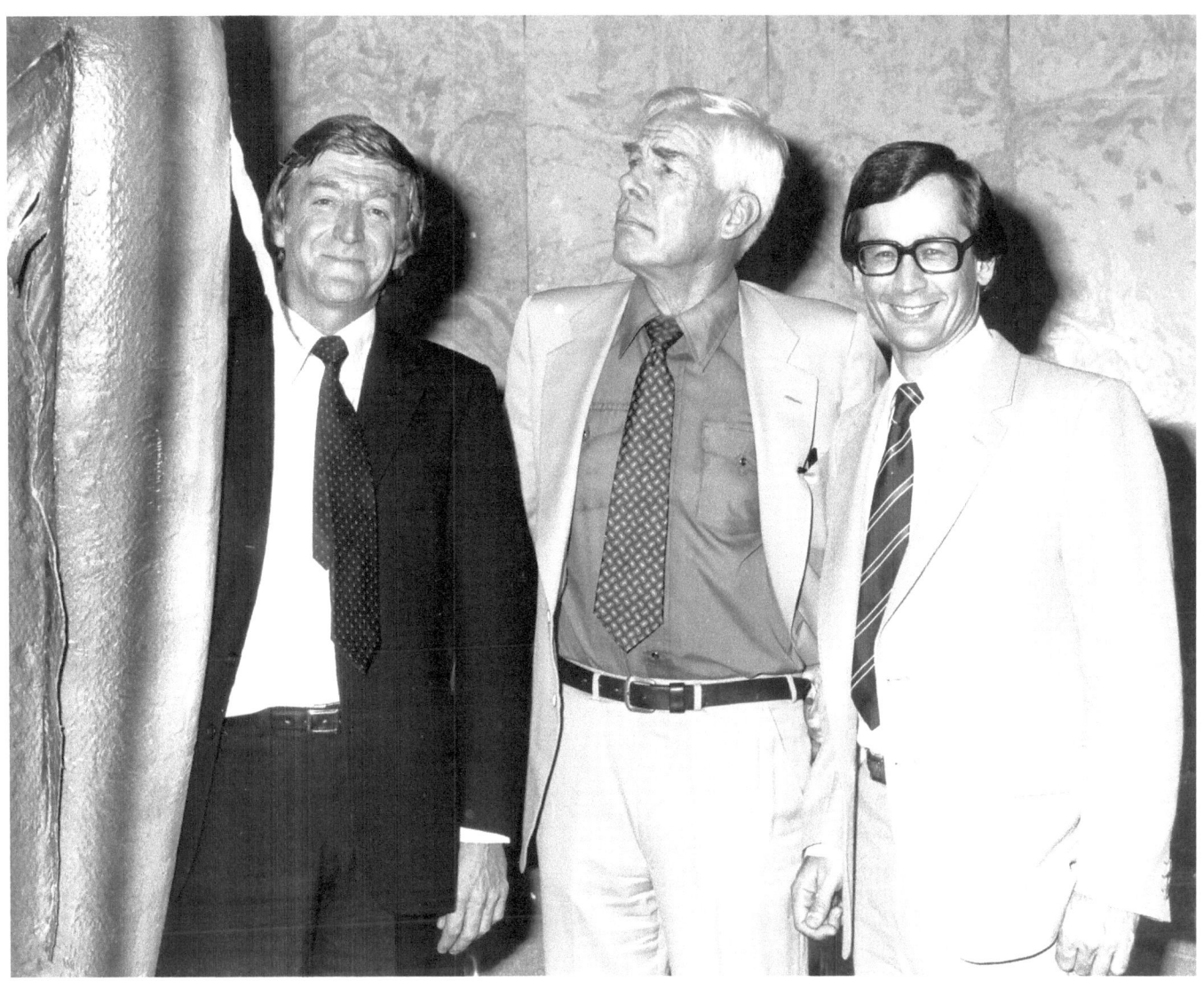

L-R: Sir Michael Parkinson, actor Lee Marvin and Australian businessman, philanthropist, explorer (and much more) Richard (Dick) Smith, A.O.

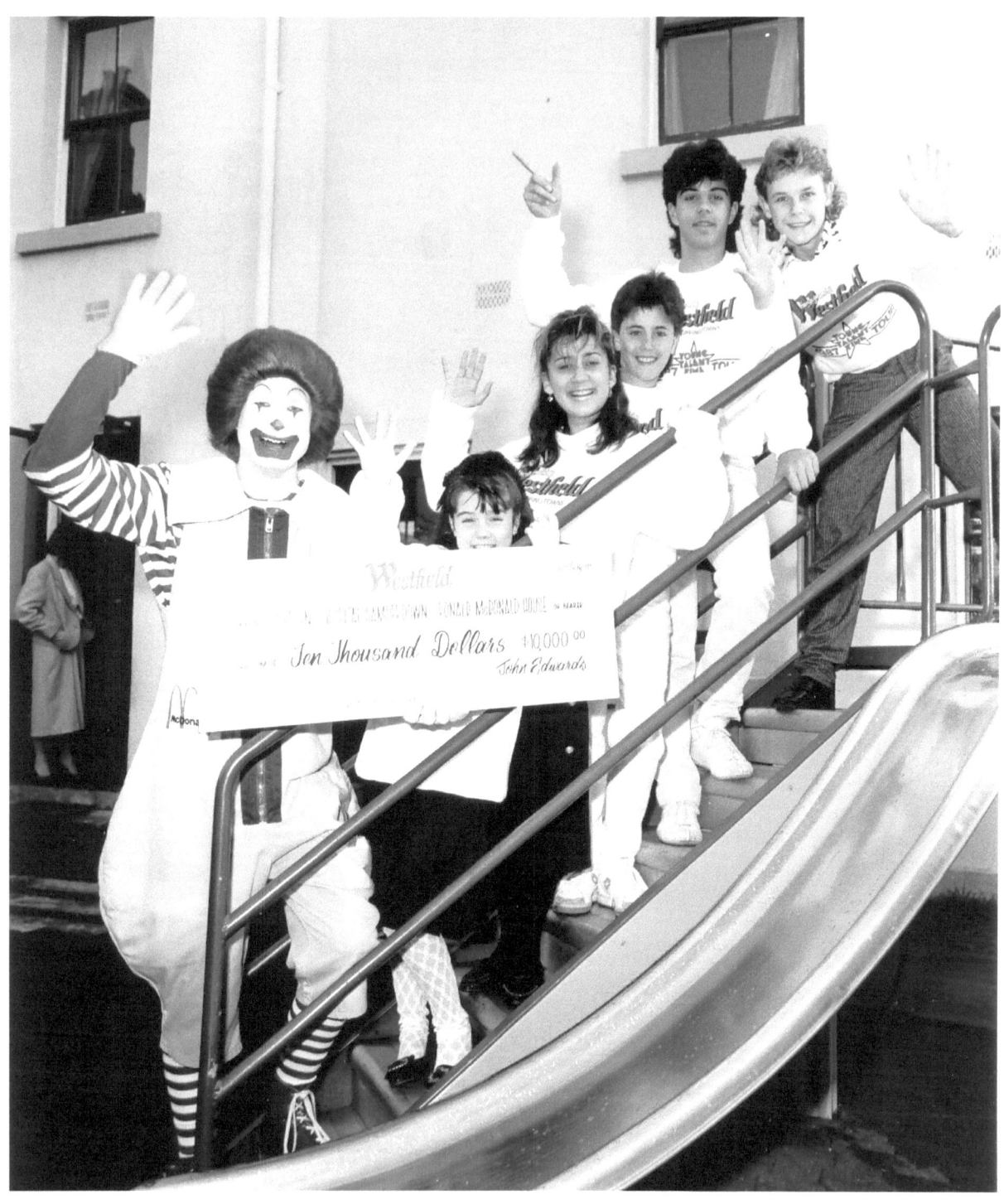

A publicity shot for Westfield's featuring the cast of hit Network Ten show *Young Talent Time*.

The little girl behind Ronald McDonald, almost obscured by the check, is a young Tina Arena!

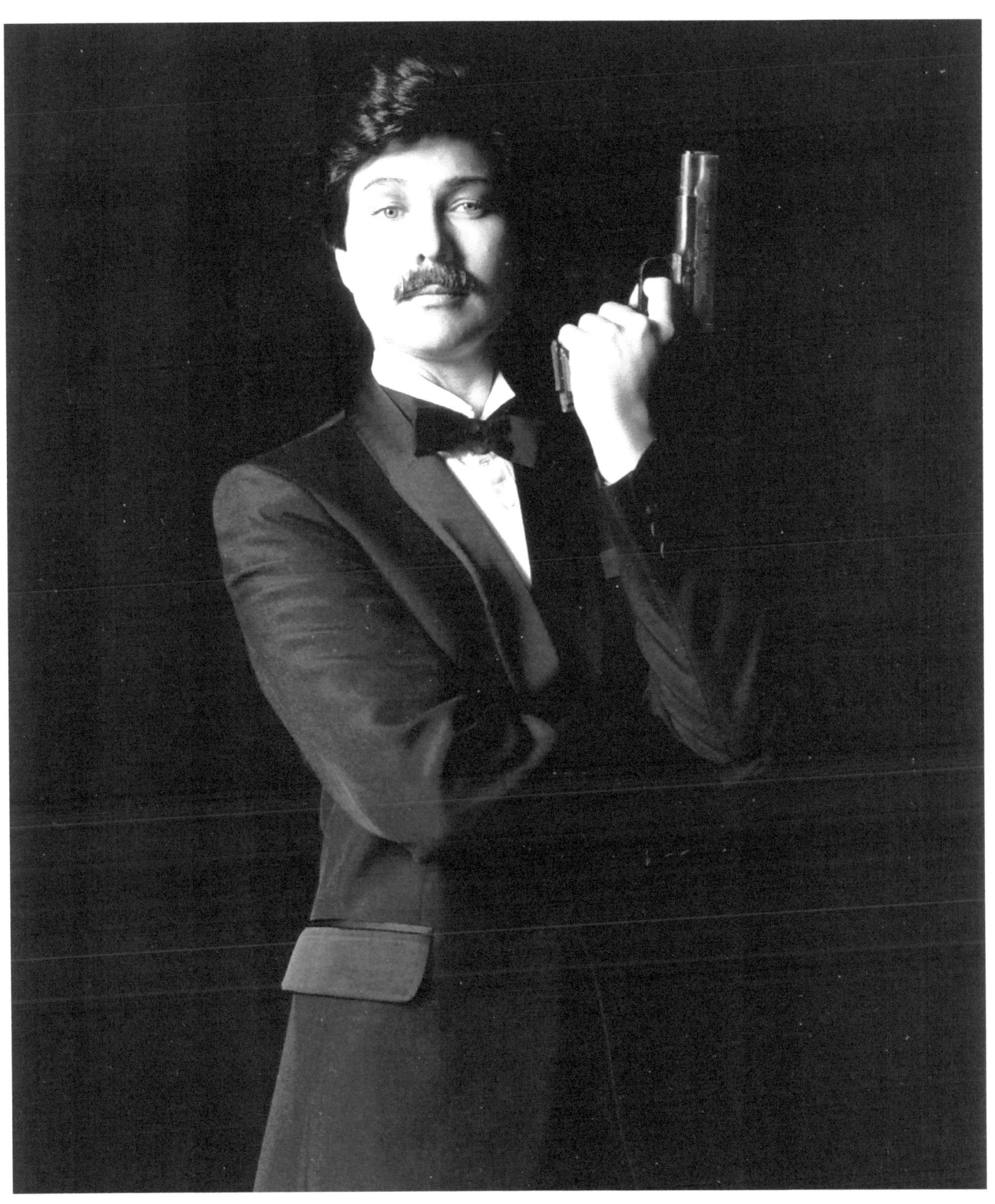

A certain female Australian TV presenter dresses up as James Bond.
Guess who? (I'm not telling!)

Val Lehman from hit Network Ten series *Prisoner*.

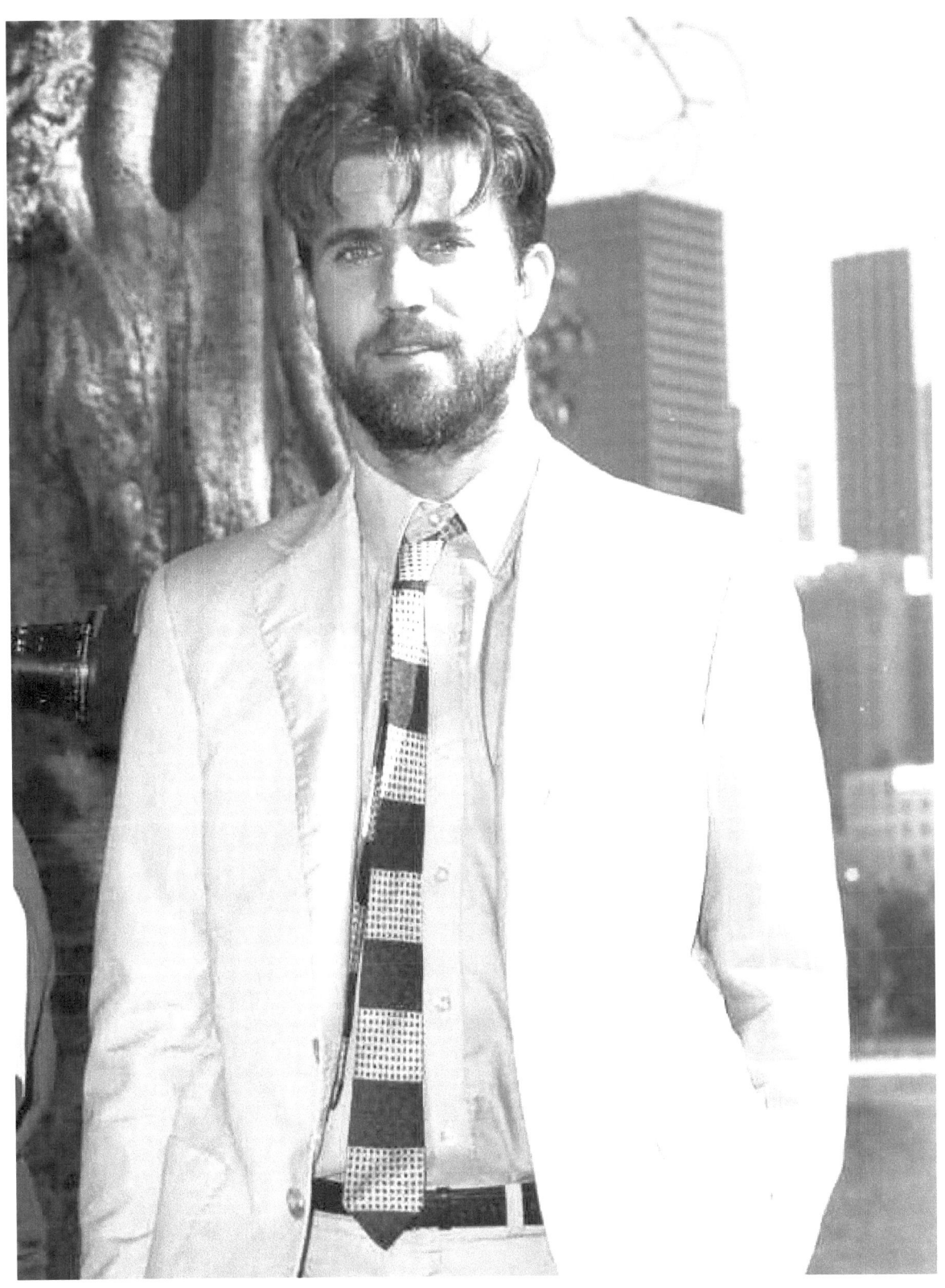

A young Mel Gibson.

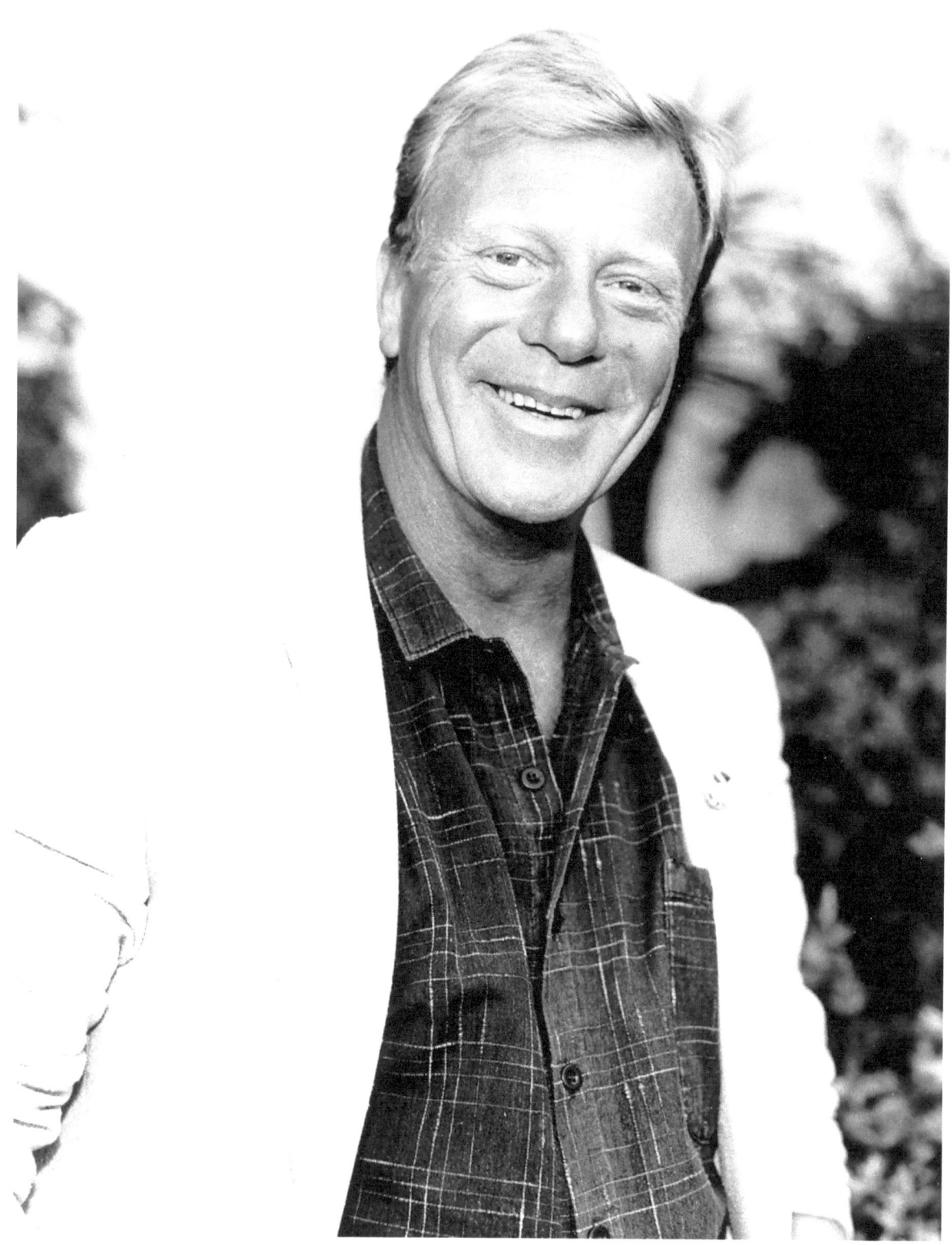

Australian actor Mr Jack Thompson, A.M.

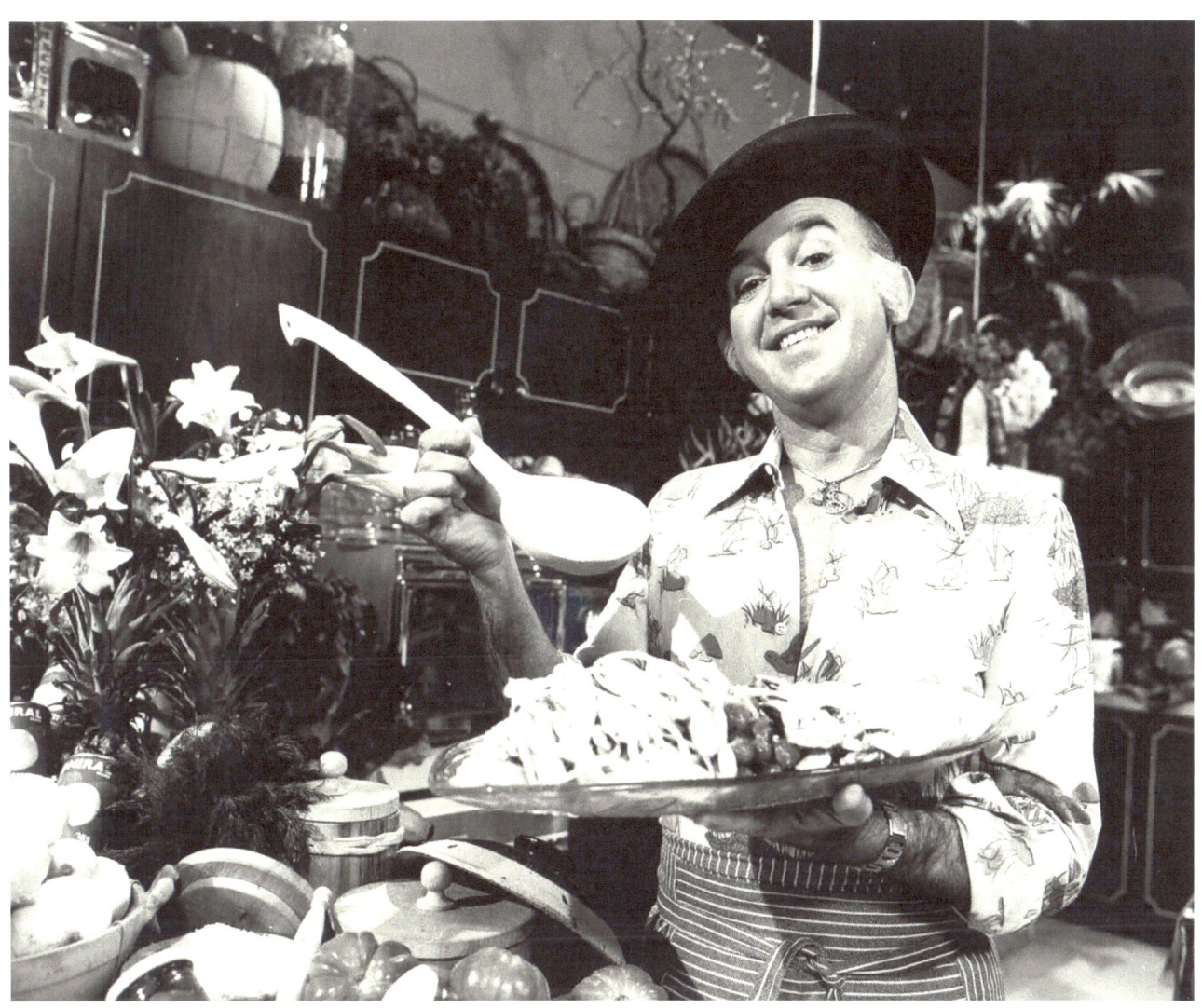

The likable, funny and hard-working celebrity TV cook Bernard King of *King's Kitchen*.

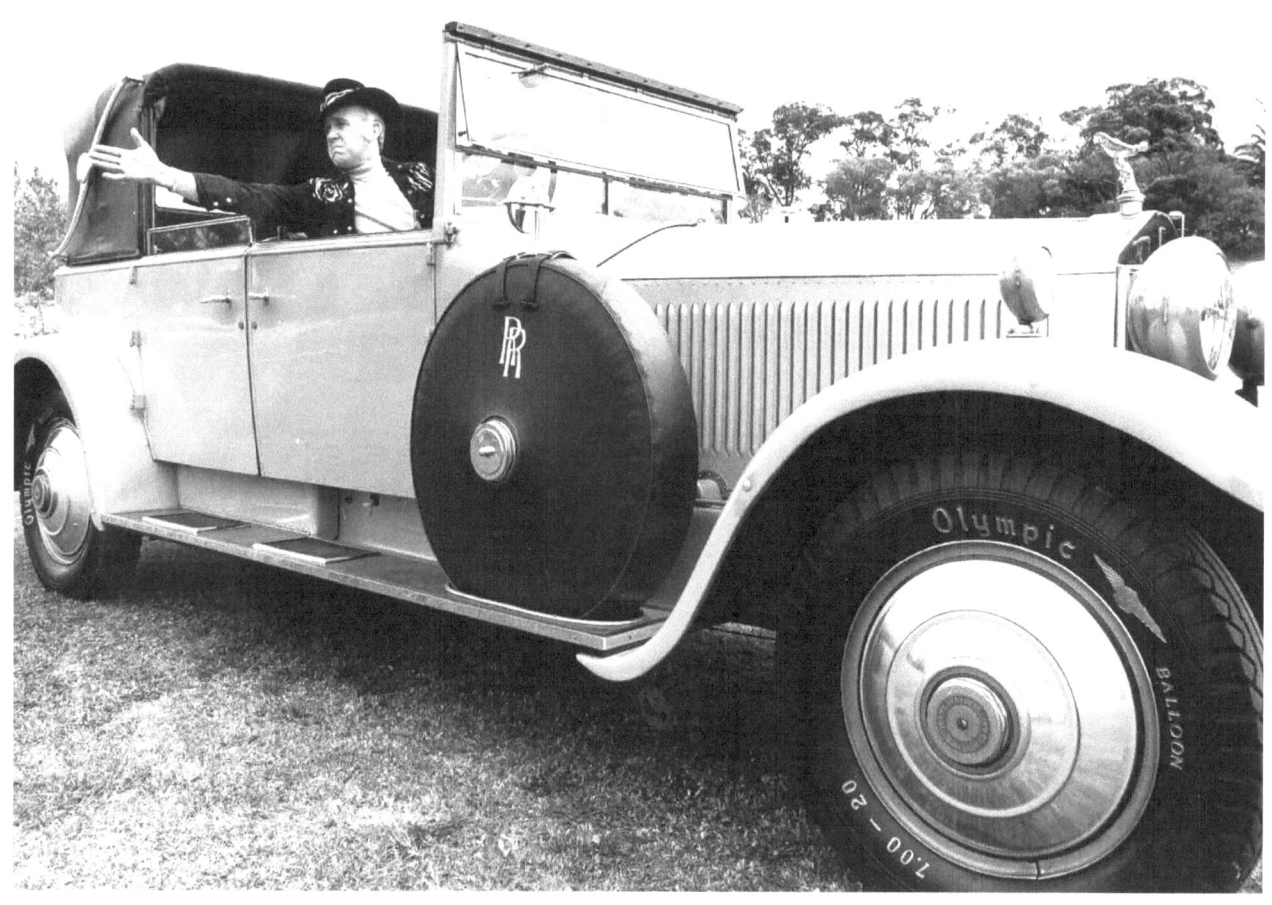

Bernard King in his Rolls Royce. He often suggested great shot ideas himself.

The author of his book fondly remembers the late Bernard King, who was not only hard working and greatly talented, but also wonderful sense of humor. His humor was sometimes directed to the author in public; on one occasion much to the author's embarrassment when he was with his wife as Bernard made an appearance at Westfield's!

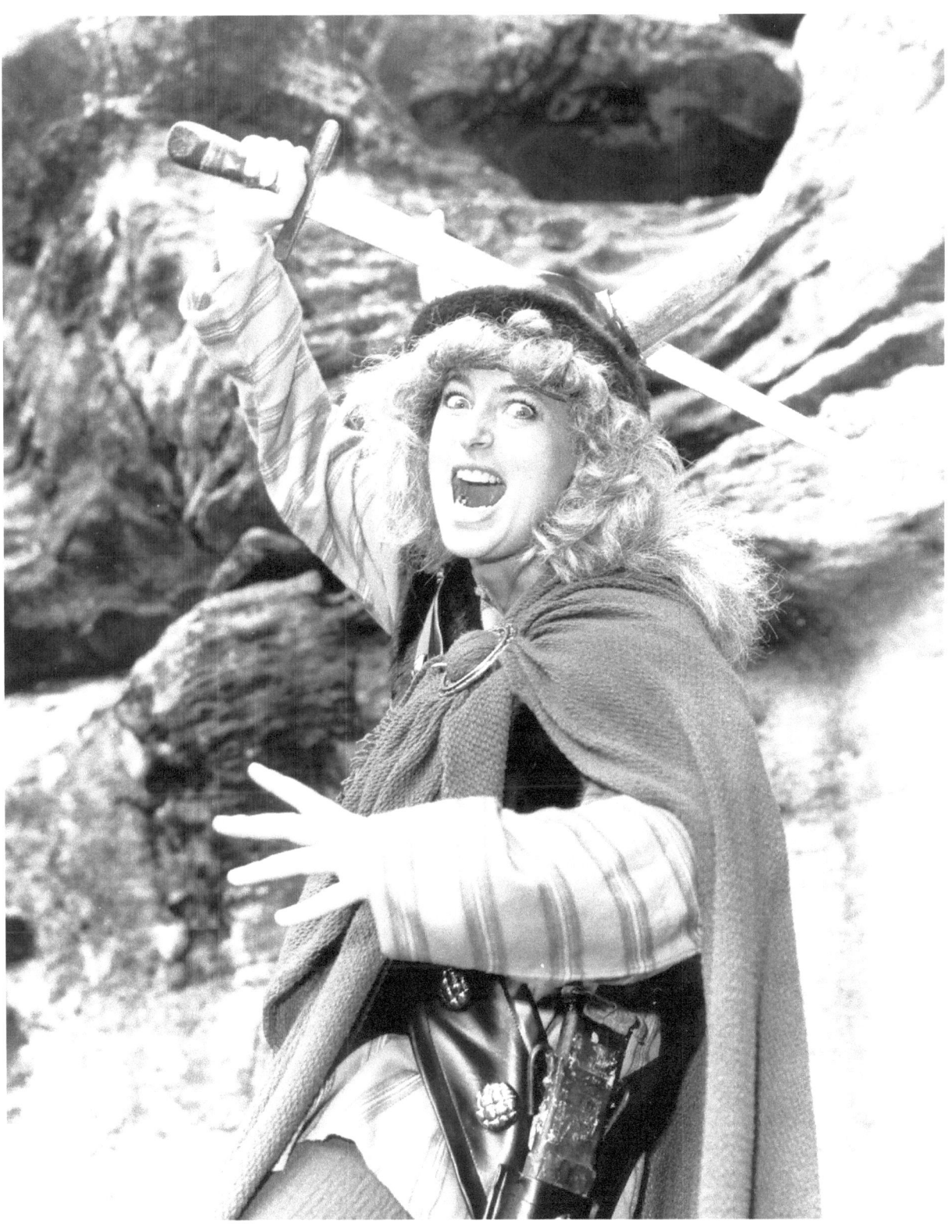

Australian media personality playing Viking!

A young Mark Holden.

One of Australia's many seriously talented:

Ita Buttrose, A.O. O.B.E.

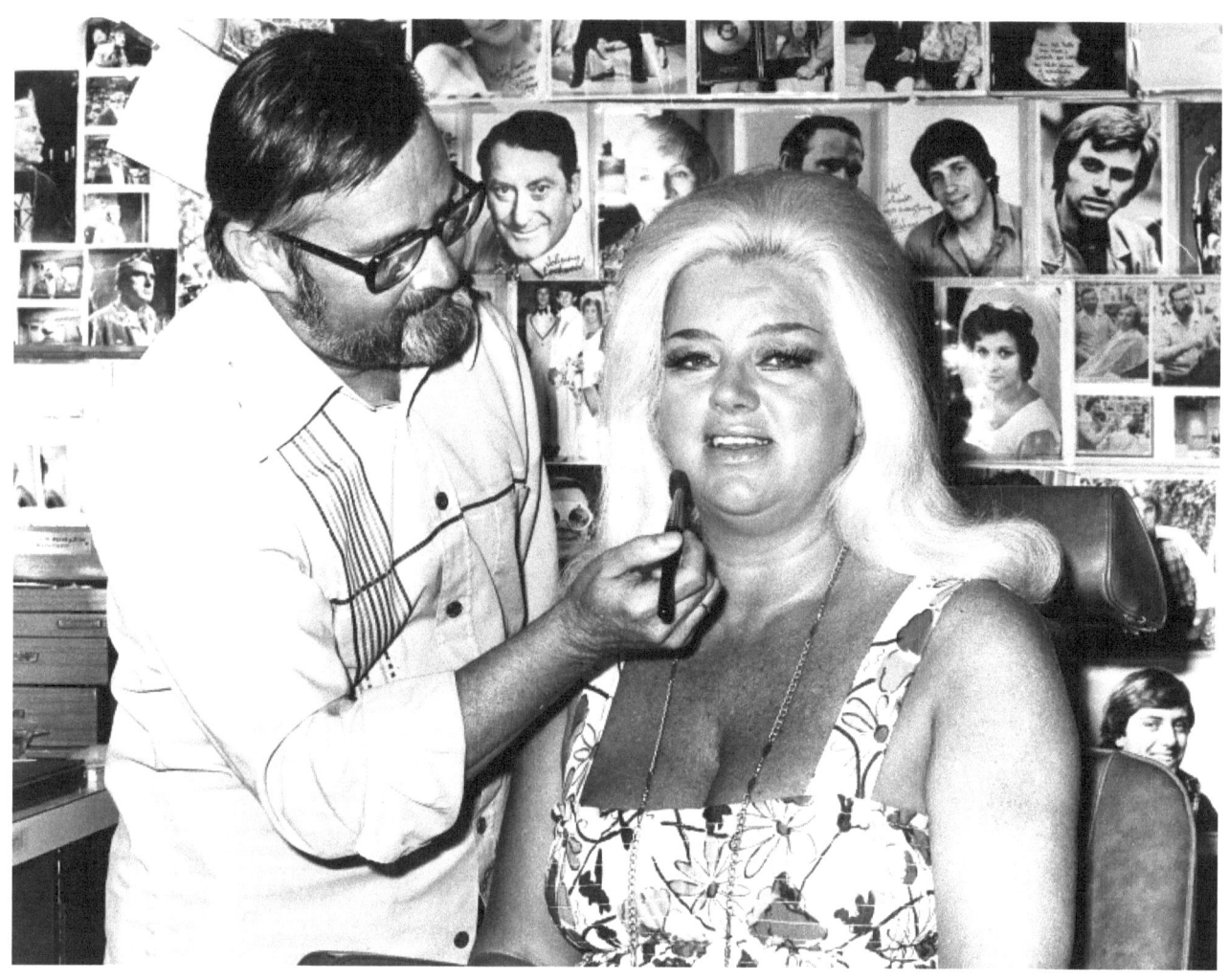

Diana Dors in the makeup room.

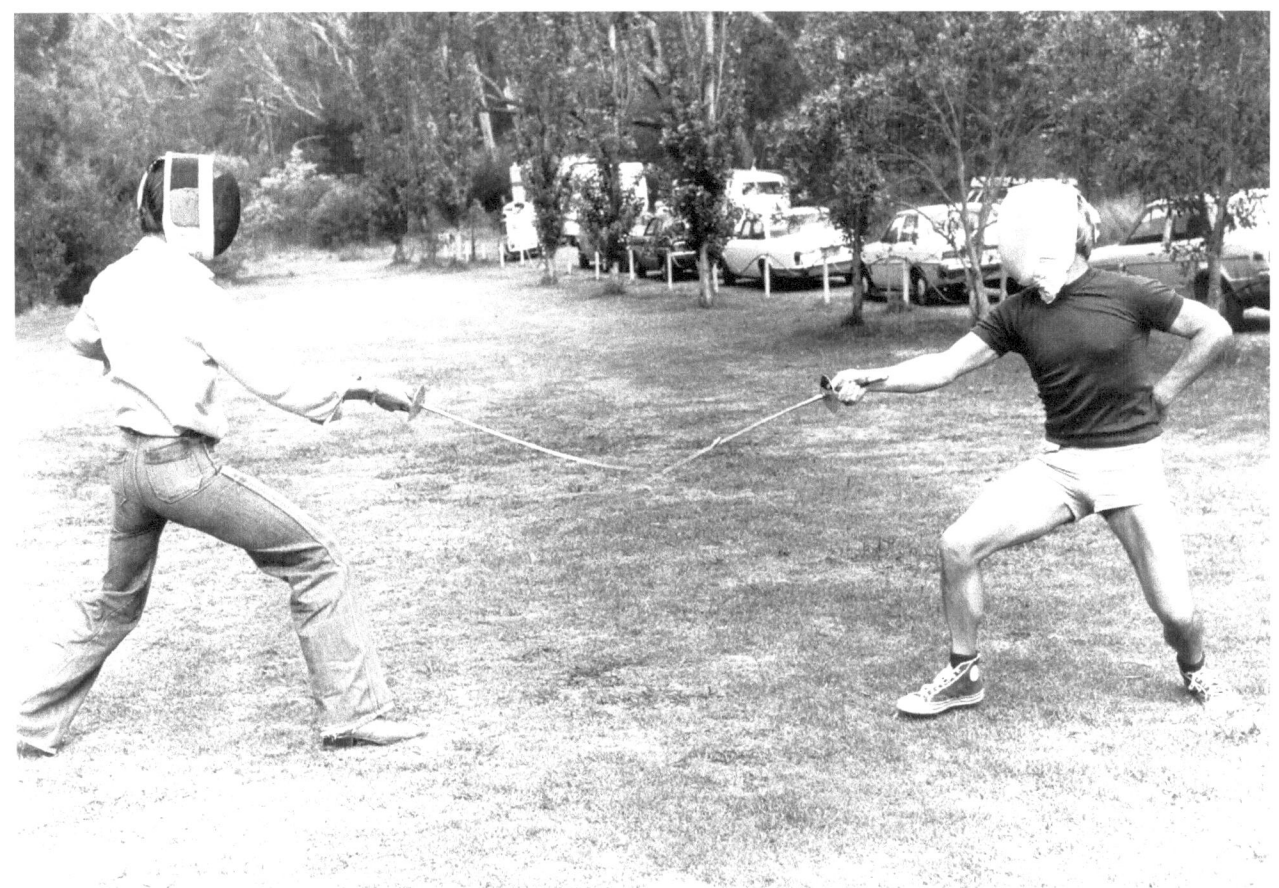

The author (right) – very carefully! – fencing in a park with an ex-British S.A.S. soldier and trainer. What can I say? He let me win sometimes! If you have a friend who's handy with a camera it's always nice to receive a favor to keep in your collection.

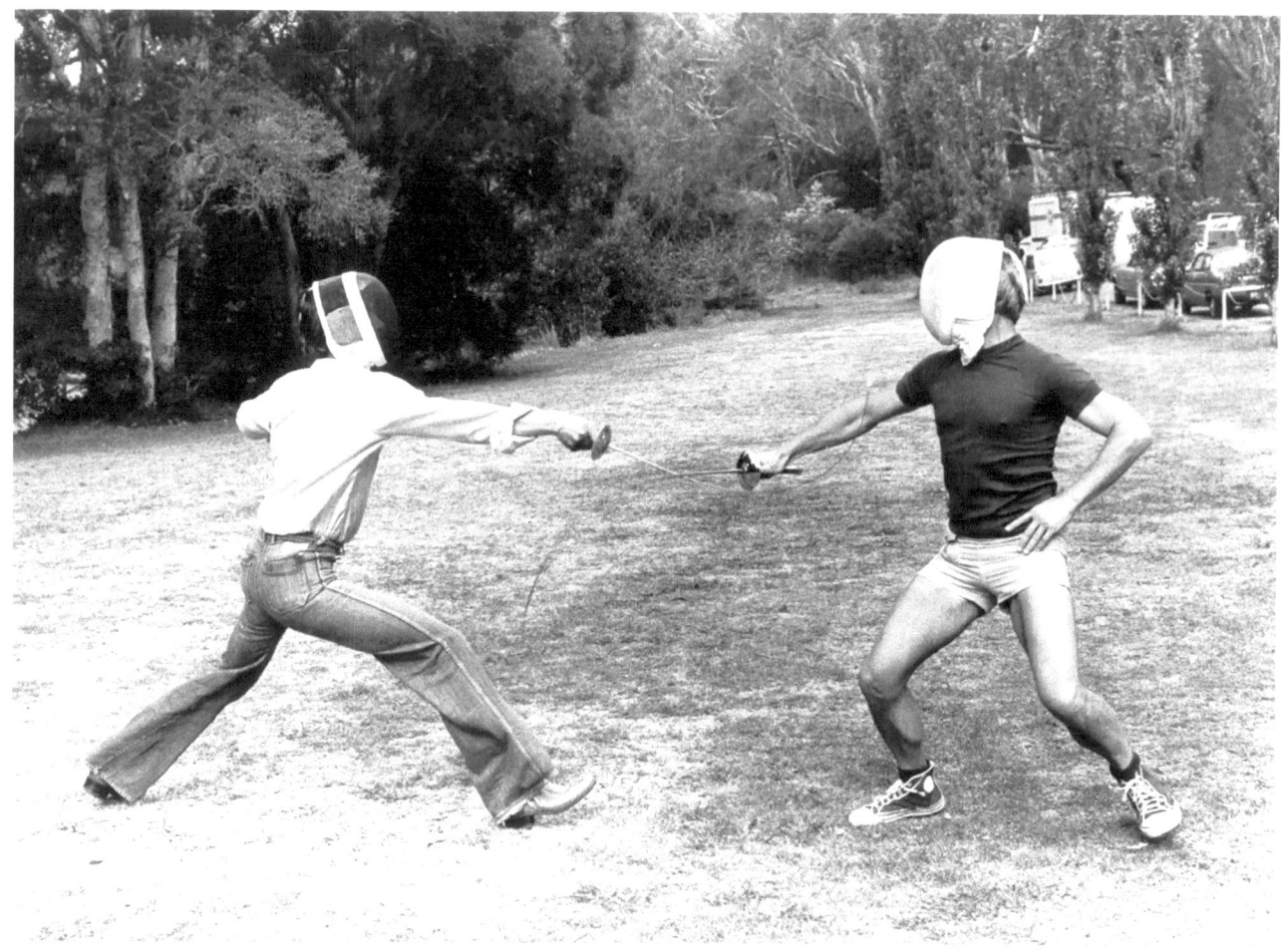
My ex-British S.A.S. friend "goes in for the kill." I often wondered how I competed with my friend. I was in the Regimental Police Unit, RAMC, British Army of the Rhine, Berlin.

Don Lane (left), our "Lanky Yank" and friends.

(Right) Mike Walsh.

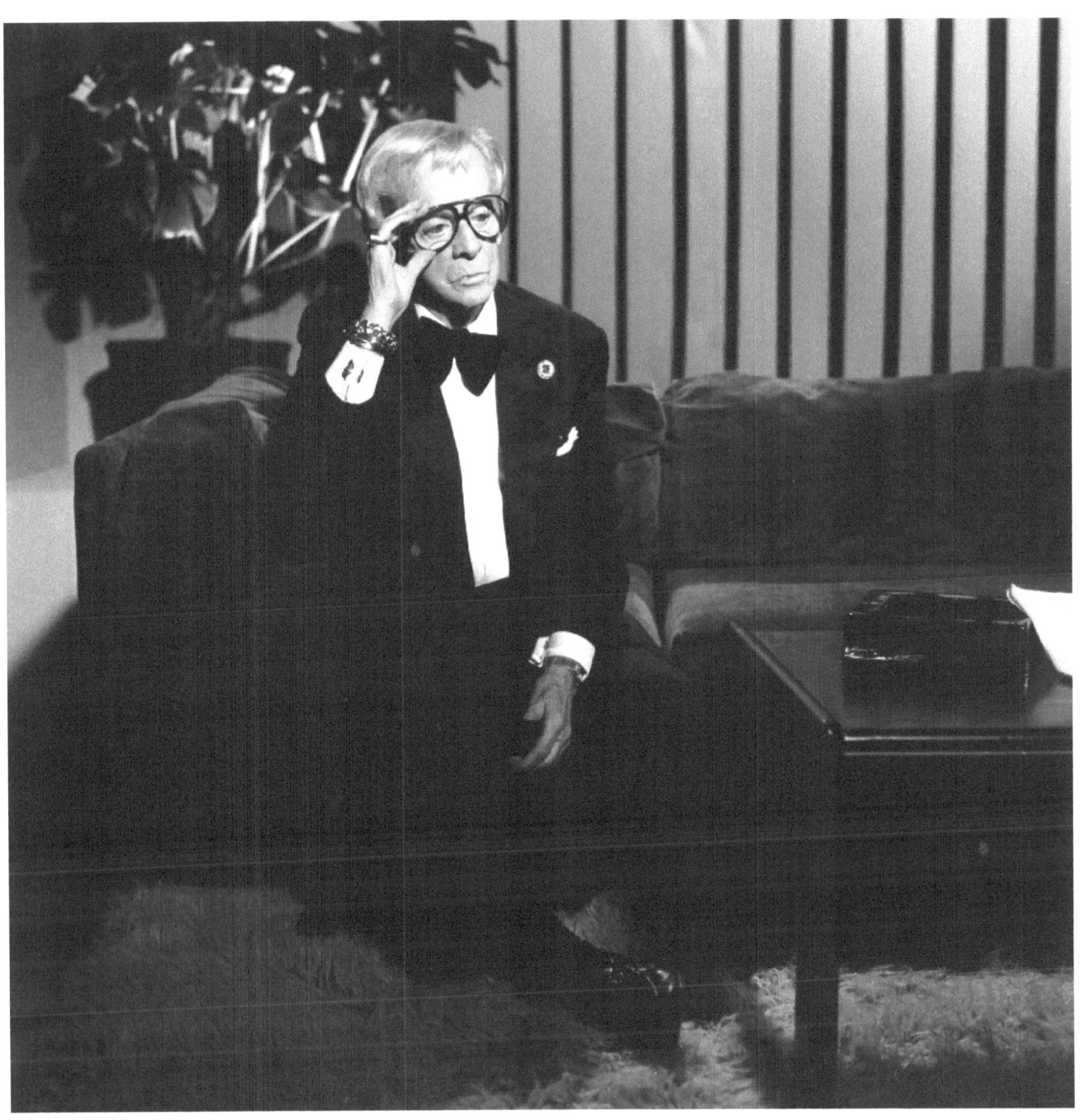

Sir Robert Helpmann.

Barry Buchanan

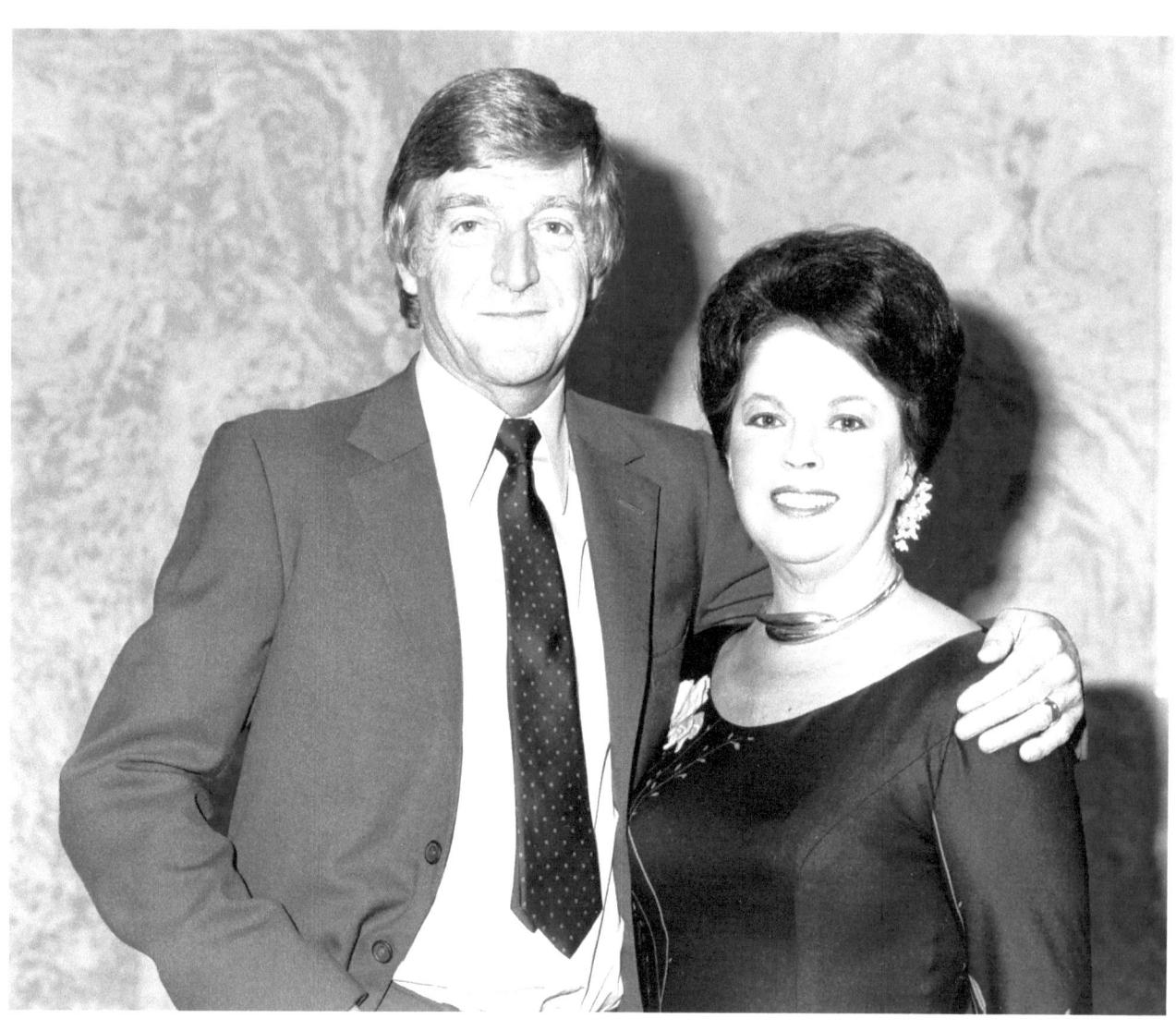

Sir Michael Parkinson and Shirley Temple Black.

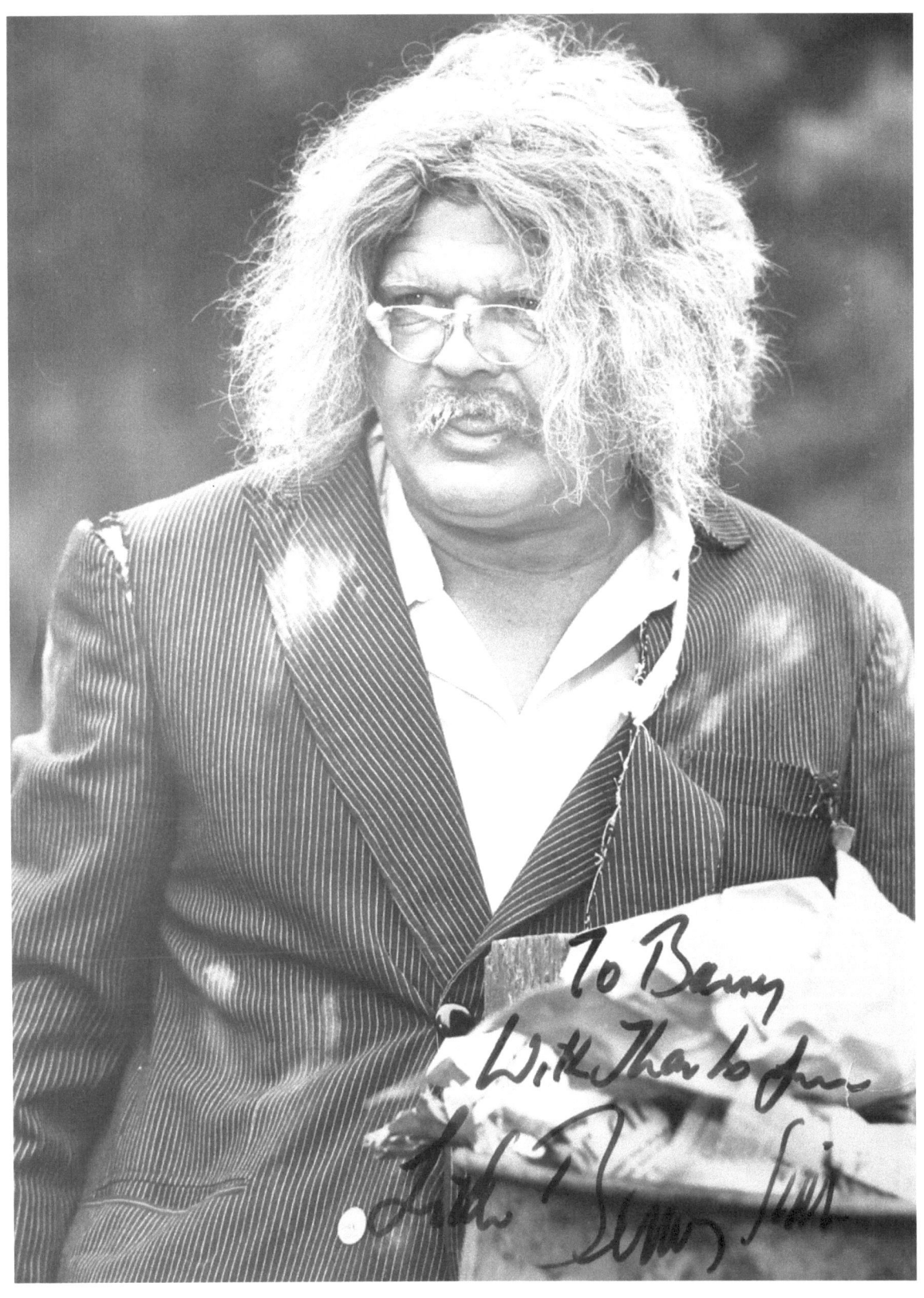

Signed "To Barry With Thanks from Little Benny Hill."

I hope you've enjoyed this "getting started" guide to professional photography with plenty of examples to study and guide you along the way.

So, how can you get into professional photography these days? For a start, try freelancing. Go out and get whatever you can. Attend events and hang around places where you might get a shot. Be sure to have a photographic media card with you, if you have one; otherwise you can start with interesting and unique shots where you live and try selling them to your local paper.

It is necessary these days to have a good digital camera and perhaps a multifunction printer with scanner if you have a film camera. With digital cameras, make sure you choose carefully. Some of them are far too small to handle well and others have an identity crisis, not knowing if they are stills cameras or video cameras. When you buy a camera, become familiar with it quickly and make sure you make good use of the instruction manual. Go for the reasonable-sized camera with less "bells and whistles" you don't need. When considering zoom, optical zoom counts. Pay no attention to hype about large figures for digital zoom. The lens is important, as is Optical Image Stabilization (OIS), obviously. I find Panasonic's digital cameras to be great. There are probably other excellent ones, but I can't give any recommendations since I don't have the money to buy many of them and I can't try them all out.

In summary, to make it you have to be on time, quick, professional and be able to "bounce off people." Remember that *getting publicity* is part of your job. Practice is extremely important. Immerse yourself in it, and above all, enjoy yourself.

You may wonder why I chose the shots I did. I have thousands, and these just happened to be handy. They are just as good as any for illustrating professional photography. Remember, most photographers are commercial photographers, not artistic photographers.

I hope you liked this short, sharp book on getting started. Please keep a look out for my next book on digital photography. You can contact me by email at tvstills@gmail.com.

www.ingramcontent.com/pod-product-compliance
Lightning Source LLC
Chambersburg PA
CBHW051047180526
45172CB00002B/549